To: Arthur Fro
Christmas

MW00603446

Tennessee Post Office Murals

Howard Hull

The Overmountain Press

JOHNSON CITY, TENNESSEE

ISBN 1-57072-030-4
Copyright © 1996 by Howard Hull
Printed in the United States of America
All Rights Reserved

1 2 3 4 5 6 7 8 9 0

This book is dedicated to Frank.

CONTENTS

INTRODUCTION

Murals are pictures made for a particular wall. Usually they are concerned with a theme that portrays something about the culture of the area in which they are found. Many are inspirational in nature and function in the manner of early stained glass windows as a method of eliciting a kind of thought or behavior. Occasionally one is painted that is pure decorative design with no literal meaning. These are meant to be appreciated solely for aesthetic reasons.

The idea of the mural has been around for thousands of years. Even prehistoric cave drawings have a muralistic quality, depicting various aspects of hunting or clashes between warring tribes. They can be found in Egyptian tombs and on the walls of Pompeii. In Mexico, one finds the outer surfaces of public buildings enriched by the vivid colors of murals by such well-known and respected painters as Clemente Orozco and Diego Rivera. Throughout the United States, they can be found in many government buildings.

While murals are generally thought of as being painted, they are also constructed of many other types of material. Some of these are ceramic tile, stone, concrete, wood, and glass. Whatever the material, or whenever they are found, one can be sure that the visual pleasure derived from these artistic efforts is constant and enduring. The world could use more of them.

PREFACE

This book was written as an effort to make the people of Tennessee aware of the state's post office murals and to present information about them. It is hoped that eventually more will be restored so that all will be available to the public as they looked when originally created.

Research for the book revealed that while all of the artists who executed the murals were very competent, their national reputations varied greatly. Consequently, the biographical information available about them ranges from a considerable amount for some to almost nothing for others. Some have had books written about them while others are rarely mentioned, if at all, in pertinent literature. For that reason, there is some variance as to what is written in this book about each artist.

ACKNOWLEDGMENTS

Anyone who has ever been involved in even a small amount of research realizes it is seldom accomplished by one person. There is usually help from many people and a variety of sources, depending upon the complexity and depth of the research.

In the writing of this book, I received assistance from a number of people and organizations. I would like to express my sincere appreciation to the following: Dave Thomas; Scott Sharp; Don Battles; James Cowan; Faye Hayes; Frank and Roberta Sech; Martha Peterman; Susan Smith; Judge Thomas Hull; Linda Chattin; Sara McNeil; Judy Throm of the Smithsonian Institution; Byron Pate; Judy Striet; my brother, Dr. Robert Hull; the National Archives in Washington, D.C.; the University of Tennessee College of Education for financial support; and especially my two graduate assistants, Julie Seaton and Ginny Maier, who never said "I can't" when something needed to be done.

THE SECTION OF FINE ARTS

About sixty years ago, the United States government got into the art business. With the approval of President Franklin D. Roosevelt, it instituted a series of programs to keep artists working during the Depression years. The whole affair began in 1933 with the Public Works of Art Project (PWAP) and ended in 1943 as the government's money, attention, and energy shifted to winning World War II.[1]

In all, there were four major programs: PWAP, which employed various professional artists to create works of art for the government; the Treasury Relief Art Project (TRAP), which was funded essentially from appropriations for public buildings; the Works Progress Administration's Federal Art Project (WPA/FAP); and the Treasury Section of Fine Arts.[2]

The PWAP defined art as "sculpture, painting, design, and the product of a craft, which, in the opinion of those doing the undertaking, constituted the embellishment of public property."[3] Artists were encouraged to work in a mode which was compatible to their own individual natures. The one restriction was that they stress the American scene.[4] The PWAP was a limited and short-lived program, employing relatively few of the artists in the United States in need of work. It only lasted about six months, coming to an end in early summer of 1934.[5]

TRAP was financed by the WPA and began during the summer of 1935.[6] It was an effort to remove artists from relief roles and to decorate federal buildings. Eventually, it employed about 446 persons, seventy-five percent of whom were on relief. It was discontinued in 1939.[7] During the years of operation, the program had produced eighty-nine murals and forty-three sculptures for federal buildings and housing projects. In addition, about ten thousand easel paintings were allocated to government institutions and embassies.[8] The WPA/FAP and TRAP were very successful in that they removed many artists from relief roles and gave them opportunities to use their creative abilities to enhance

public buildings.

The Treasury Section of Fine Arts, from which citizens of Tennessee would receive considerable benefit, was organized under Secretary of the Treasury Henry Morganthau, Jr., on October 16, 1934.[9] The original idea for the Section came from Edward Bruce, who had been active in PWAP. He "proposed that a 'Division of Fine Arts' be established in the Treasury Department and that the president, by executive order, set aside one percent of the cost of new federal buildings for their embellishment."[10] That meant that if a new post office was to cost $50,000 to build, $500 would be set aside for decoration. Most commissions for murals were between $500 and $2,000, with a very expensive one going to Anton Refregier for the Rincon Annex in San Francisco in the amount of $26,000.[11]

As a part of President Roosevelt's "New Deal," the Section was involved in the production of murals for hundreds of new post offices to be built throughout the United States. Tennessee was lucky in that it received its fair share—and more than many others. The leaders of the Section were not part of the governmental bureaucracy. Edward Bruce, Edward Rowan, and Forbes Watson were all art people.[12] Bruce was primarily a landscape painter with a background in business. He had organized and directed other government projects and was knowledgeable of Washington politics. Watson, a writer and art critic, had worked for the *New York Evening Post* and the *World* and was owner, editor, and publisher of *The Arts*, a magazine exploring various aspects of artistic endeavors.[13] Rowan was a well-known watercolorist and an art historian with a master's degree from Harvard.[14] Having a built-in budget of one percent of the amount allocated by Congress for the construction of public buildings relieved the pressure of trying to raise private contributions.

Initially, artists such as Thomas Hart Benton, George Biddle, and Reginald Marsh, all with excellent reputations in the art community, were chosen to provide works for buildings in Washington. Other artists throughout the

country entered competitions to provide murals for each of eleven hundred new post offices to be built by the government between the years of 1937 and 1943. Most notable of these was a national competition known as the "Forty-Eight State Competition" of 1939.[15] It was a nationwide contest to design murals for a designated post office in each state. The winning sketches were photographed by *Life* magazine and were reproduced in an article in the December 4, 1939, issue.[16] Among those were David Stone Martin's mural for Lenoir City entitled *Electrification*. Various other regional and national competitions were held between 1937 and 1943. If an artist failed to win a particular competition, but his or her work seemed to be of high quality, there was a good possibility the artist would be given a commission elsewhere.

These anonymous competitions provided opportunities for many lesser-known artists, including women, to receive commissions. Of the commissions in Tennessee, eleven were given to women artists. Most well-known of those are Minna Citron, Marion Greenwood, Marguerite Zorach, Anne Poor, and the sculptor Belle Kinney.

The Section was committed to making art a part of daily life in cities, small towns, and rural areas across America.[17] There are hundreds of these "post office murals" scattered throughout the United States, mostly in smaller cities. In Tennessee, there were initially thirty, including two sculptures in the round and four relief sculptures. Tennesseans are fortunate that most of the original thirty are still in existence and available to the public. A sculpture by Belle Kinney for Nashville and a mural painted by F. Louis Mora for Clarksville have been destroyed.[18]

In these new post offices, art could be seen by ordinary citizens as they conducted normal business.[19] Each mural is in some way related to the community. History, business, and environment were all considered as viable options for subject matter. The works are representative of various styles, some more pronounced than others. In most, the subject matter is recognizable, although some-

times used in a symbolic manner rather than a literal interpretation of events.

The idea of having anonymous competitions was seen as a way of ensuring that local politics did not influence the selection of the artist. With any government project, certain groups such as fraternal organizations, newspapers, local art organizations, and wealthy citizens usually try to see that their own personal choice of artist is selected, even if that person may or may not be as qualified as someone else. While the competitions worked reasonably well to ensure fairness, some attention seems to have been shown to various relatives of people who had already won commissions. In Tennessee, William Zorach, a sculptor with a national reputation, received a commission, as did his wife and daughter. Both Marion Greenwood and her sister, Grace, received commissions for murals, as did David Stone Martin and his wife, Thelma Martin. All were deserving and competent artists.

Most commissions were won by artists from the northeast region of the United States. At the time the competitions were held, there were many artists working in New York, Philadelphia, and Boston who had achieved national reputations. If an artist from that area received a commission to execute a mural, he or she usually visited the city where the post office was located, made some sketches, talked with various local people, including the postmaster, and then returned to the studio to paint the mural. If the mural was to be painted as a fresco, it was done on site.

Before beginning work on the final product, the artist was required to make several sketches of his or her ideas for the mural and submit them to the Section of Fine Arts in Washington for selection of the appropriate one.

When a sketch was selected, the artist was then required to complete a "cartoon." A cartoon is a full-size working model for the mural. The cartoon is made by using an opaque projector to enlarge the colored sketch. The cartoon, along with any changes recommended by the Section, was then transferred to canvas, painted, and later adhered

to the appropriate post office wall by an installer selected by the artist. In the case of a fresco, the cartoon was projected directly onto the plaster wall of the post office and then painted by the artist. Photographs were later taken of the completed mural and sent to Washington, where they became part of the National Archives. The artist was then paid the final installment of what he or she had been promised to paint the mural. Statewide, pay for completing most of the murals ranged from $500 to $750. All are considerably more valuable now. Such factors as the reputation of the artist and current condition of the mural affect the value greatly. In Tennessee, a few have been restored, enhancing their appearance and furthering the enjoyment to be gained from viewing them.

While sketches of proposed murals were scrutinized by competent jurors selected by the Section, occasionally the process broke down because the jurors could not agree, liked none of the sketches, or were simply overruled by the Section. For instance, in the competition for the Decatur, Illinois, Post Office, the disappointed committee stated, "The work is chiefly mediocre, amateurish, stale or hopelessly old-fashioned." The only sketch it liked (by Raymond Breinin) failed to meet the specifications for an "architectural presentation." Usually there was a compromise. "In this instance, the Section offered Breinin a lesser job in the Wilmette, Illinois, Post Office."[20] In any event, the Section always had the power to override the jury selection. Consequently, there was the possibility of politics playing a part in the selection to some degree. In certain cases competitions were limited to a small area, and in at least one case to only one state (Montana), making certain that a regional artist would be selected.[21]

In a few instances, important public individuals attempted to refuse the mural or have it moved or altered. "The postmaster of Jenkintown, Pennsylvania, gave the completed mural to the local high school."[22] In Kennebunkport, Maine, Booth Tarkington, a summer resident, was a leader in a campaign to raise money to have

the mural of a contemporary beach scene replaced with one of the historic harbor. "The first mural, painted in 1941, was widely criticized at the time but allowed to remain in place until after the war."[23] Senator Wallace H. White of Maine was quoted as saying, "The mural is a picture which, to speak frankly, depicts a number of fat women, scantily clad, disporting themselves on a beach."[24] Tarkington, on the other hand, insisted that "New England Puritanism has nothing to do with it—the women were just plain ugly."[25]

In the long run, however, support outweighed criticism of the mural project, lending credence to the Section's belief that art could stimulate a deeper sense of culture and help people confront the Depression.[26] Even where murals were criticized, it was considered a healthy intent, something for people to talk about. An awareness of art and beauty was realized. People asked the government officials to provide more of the same. They saw it as a learning experience. When an artist painted a fresco, he or she worked directly on the wall, showing new progress each day. Many people came to watch, fascinated by the technique. In Natick, Massachusetts, Hollis Holbrook was impressed with both the number and variety of people who watched him: "You wouldn't believe it but there are dozens that come in every day just to see the forms take shape. They include not only the housewives but more than twenty tradesmen, plumbers, mechanics, chauffeurs, and taxi drivers. And every person who enters asks the postmen about it. I haven't heard one remark that hasn't been highly flatter-ing."[27] Ida Abelman painted in Lewiston, Illinois. Talking about her tempera work, she said, "It was as if I had an art class. Needless to say, most people had never seen work of this sort in progress before. I am told there is no art instruction offered in the town's high school. After school session, many children gathered at the post office to ask questions. Many fathers came to ask for advice about art education for their youngsters!"[28] Perhaps the best state-ment of all came from Pleasant Hill, Missouri. "The post-

master there wrote: 'In behalf of the many smaller cities, wholly without objects of art, as ours was, may I beseech you and the treasury to give them some art, more of it, wherever you find it possible to do so. How can a finished citizen be made in an artless town?'"[29]

The Section, which had begun in October 1934, ended officially in July 1943.[30] It was a victim of World War II. President Roosevelt's 1941 budget had eliminated all non-defense projects.[31]

"During the nine years it was in existence, it awarded 1,124 mural contracts, for which it paid $1,472,199, and 289 contracts for sculpture, costing $563,529. One hundred ninety-three competitions were held, and 1,205 individual artists placed their work in federal buildings. The average price for a mural commission was $1,356, and for sculpture, $1,936."[32]

Notwithstanding a small amount of political maneuvering at local or federal levels, most competitions were honest, and in retrospect the federal government's attempt at injecting art into the lives of people at various levels of existence was seen as a huge success.

The project had been guided from its inception by the belief that art should belong to everyone in a democracy. The ability to appreciate art was not the exclusive birthright of a few people. Perhaps the past had seemed that way, but the Federal Art Project had attempted to change all that. Not only was it a positive and enlightening event for the viewers of the artwork, it was an educational experience for the artist who, for the first time, felt a sincere response to his or her art, a genuine need of it, and a widespread popular interest. Artists became aware through federal sponsorship of every type of community demand for art, and they saw the prospect of greatly increased audiences. Most importantly, they began to believe that a public consciousness of art could be achieved.[32]

It is now 1995, more than fifty years after the paintings and sculptures were created. During those years, styles of art and attitudes have changed numerous times. We have

gone from realism to abstraction to realism and back again. A great number of the artists who were part of the project have passed on, but many of the murals are still on that same wall in the same small post office in that same small town where they were placed so long ago. In Tennessee, most of them are. It is a sad commentary that in too many places they have become just part of the wall, unnoticed by many who frequent the building.

1. Bernard A. Weisberger, "Federal Art for Whose Sake." *American Heritage,* December 1992, p. 20.
2. Francis V. O'Connor, *The New Deal Art Projects: An Anthology of Memoirs* (Washington, D.C.: Smithsonian Institution Press, 1972), p. 12.
3. Francis V. O'Connor, *Federal Support for the Visual Arts: The New Deal and Now* (Greenwich, Connecticut: New York Graphics Society, LTD., 1969), p. 19.
4. Ibid., p. 20.
5. Ibid., p. 21.
6. O'Connor, *The New Deal Art Projects,* p. 12.
7. Ibid.
8. O'Connor, *Federal Support for the Visual Arts,* p. 26.
9. Marlene Park and Gerald E. Markowitz, *Democratic Vistas: Post Offices and Public Art in the New Deal* (Philadelphia: Temple University Press, 1984), p. 6.
10. Ibid.
11. Ibid., p. 204.
12. Ibid., p. 7.
13. Ibid.
14. Ibid.
15. O'Connor, *Federal Support for the Visual Arts,* p. 23.
16. "Speaking of Pictures . . . This is Mural America for Rural Americans." *Life,* December 4, 1939, pp. 12-16.
17. Park and Markowitz, p. 8.
18. Ibid., p. 218.
19. Ibid., p. 8.
20. Ibid., p. 13.
21. Ibid.
22. Ibid., p. 25.
23. Ibid.
24. Ibid.
25. Ibid.
26. Park and Markowitz, p. 26.
27 Ibid., p. 26, 27.
28. Ibid., p. 27.
29. Ibid., p. 28.
30. O'Connor, *The New Deal Art Projects,* p. 20.
31. Ibid.
32. Ibid.
33. O'Connor, *Federal Support for the Visual Arts,* p. 28, 29.

THE MURALS

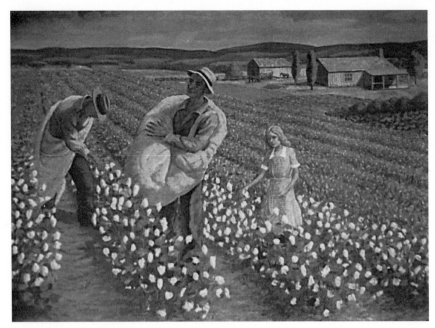

Carl Nyquist, *Picking Cotton* **(detail)**

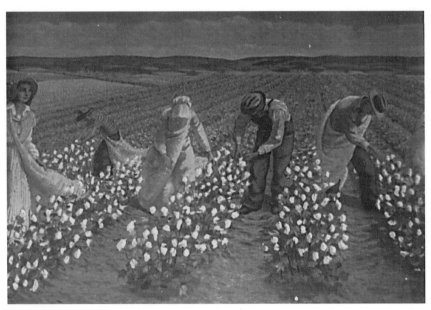

Carl Nyquist, *Picking Cotton* **(detail)**

BOLIVAR

Going down Highway 18 in southwestern Tennessee until it intersects Highway 64 will get you to Bolivar. The small, picturesque town has a mural in the old post office painted by Carl Nyquist of Washington, D.C.[1] The oil on canvas painting is thirteen feet six inches wide and five feet high.[2] For the beautiful painting the artist chose the title *Picking Cotton*.[3] The painting, quite appropriate for the land it represents, was installed in September 1941.[4]

The Description and Composition

The mural, a reflection of the long, flat cotton fields of the area, is an outstanding example of representational art, from the light brown earth color to the clothes the people are wearing. When looking at the painting, one can see a row of low hills in the distance that forms a horizon line while closer up, pickers work at the never-ending task of filling the large sacks. Rows of cotton plants march from back to front, providing a rhythmic beat to the composition. Clouds invade the clear blue of the sky, mimicking the soft, white cotton. In the right corner is a house fronted by two Lombardy poplars, and farther back there is a barn where two horses wait to be hooked to a cotton wagon nearby.

Eight people stretch across the field in various positions reflecting their endeavors, or, in two cases, lack of endeavors, as is evidenced by the young woman in the bonnet on the far left. She stares into space, perhaps dreaming of another time and place, the cotton sack only an ornament at her side. There is also a younger blonde girl on the right who isn't working. She seems to have been placed in the painting to add youth and as a shape to balance the composition. The only other woman in the picture works diligently alongside the men as they extract the cotton from the plants.

While the painting is well executed and enjoyable to look at, it may seem a bit misleading to some. It is generally understood that people don't pick cotton from fresh, green

plants. The time appears to be more like midsummer than autumn. Since the overall color system is predominantly on the cool side, the green, however, works better as a color for the painting, and that after all is what is important.

The Mural's Relation to History

Hardeman County, where Bolivar is located, was established in 1823. The city is named after Simon Bolivar, the patriot and liberator of Venezuela and Colombia in South America.

The early Hatchie River Valley settlement was an important trading area for the Chickasaw Indians of southern Tennessee and northern Mississippi. Cotton has been grown in the fertile soil there for many decades. In antebellum days, large mansions dotted the countryside, surrounded by fields of white cotton.

Perhaps the mural's relationship to history can best be found in the clothing of the individuals. The long cotton dresses were still worn by women in the fields during the early 1930s. This appears to be the time depicted in the mural. Those were Depression years, and sometimes people involved in agriculture were better off than others. On many occasions, entire families of small landowners congregated in the fields to harvest the white cotton. The men wore loose-fitting shirts and trousers and wide-brimmed hats as protection from the hot sun. The bonnets worn by the women served the same purpose.

The Artist

Other than the fact that Carl Nyquist lived in Washington, D.C., when the painting was completed, information regarding his career as an artist is extremely scarce or nonexistent. Many letters were written and telephone calls made (including one to a Nyquist in Washington), in an attempt to track down leads regarding the artist. No information was forthcoming. He was a very competent artist, but the painting was done more than fifty years ago. Apparently he was not well known, and few if any records

regarding his work have been published.

1. Rowan to Nyquist, January 9, 1941.
2. Nyquist to Rowan, February 10, 1941, Washington, D.C.
3. Ibid.
4. Rowan to the Commissioner of Public Buildings, September 11, 1941.

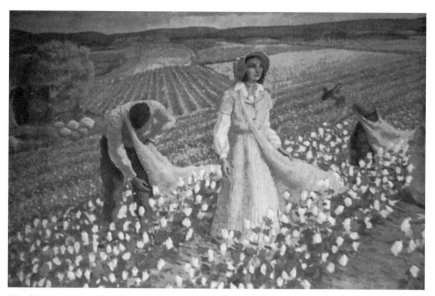

Carl Nyquist, *Picking Cotton* (detail)

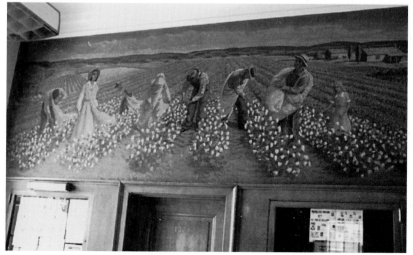

Carl Nyquist, *Picking Cotton*

CAMDEN

Camden is located at the intersection of Highways 69 and 70, about twenty-five miles north of I-40 in West Tennessee. The post office mural there is by John H. Fyfe, a longtime resident of Tennessee.[1] It is still in the original post office for which it was painted. The oil on canvas painting is twelve feet by four feet and is entitled *Mail Delivery to Tranquility—The First Post Office in Benton County*.[2] It was installed April 14, 1938.[3] Mr. Fyfe received the sum of $510 to execute the painting.[4]

The Description and Composition

The mural, a representation of a moment from history, is an early pioneer scene showing the post office with the sign identifying it over the only door. Other cabins are seen in the background. The men are dressed in rough frontier clothing, including buckskin. A woman stands in the door of the post office while another in a gray homespun dress waits just outside with a small boy. Her husband talks about information he has received to a friend wearing a coonskin cap and leaning on a long rifle while the mail carrier, as if waiting for a return message, sits astride a horse being held by a teenage boy.

The illusion of depth in the painting is accentuated by diagonal lines of green vegetation toward the center and size differences of people from the man dressed in coonskin to the small figure barely discernible in the doorway of the cabin.

In the left section of the picture are two people engaged in typical frontier activities. The man clears more land as he swings his axe mightily toward a large beech tree. The woman stirring the boiling mixture in the large pot is probably making lye soap. The total composition, bordered on the left and right by large trees and with cabins in the middle set against a forest of soft greens, is a treat for any eye.

The Mural's Relation to History

Tranquility was a frontier settlement about one mile west of the present city of Camden on one of the postal routes leading westward from Nashville toward Memphis. This route was called Glovers Trace and was little more than an Indian trail through the forest, impassable to all travel except by horseback.[5]

The first stage line which passed through the Benton County area and carried mail as well as passengers from Nashville to Memphis was established in 1831.[6] Benton became a county on February 7, 1836,[7] and was named for Thomas Hart Benton, politician and grandfather of the Missouri artist Thomas Hart Benton.[8]

The eastern border of the county is formed by the Tennessee River. Hardwood trees such as black gum, oak, and walnut abound in its forests. The temperate climate and abundant water have made it an ideal agricultural area. Since the early 1800s, various crops have been grown, including corn, wheat, oats, tobacco, and sugarcane for the making of molasses by the old horse-powered sorghum mills. After the cane was cut, a team was hitched to a long pole, which was slowly moved in a circle to drive the machinery which crushes the juice from the sweet stalks. As in most farming communities, early social activities in Camden centered around house meetings, quilting, log rollings, barn dances, and revivals, punctuated by a considerable amount of drinking and fighting. Since Benton County was pro-slavery and pro-secessionist, not one person voted for Lincoln in that election.[9] The primitive dress and activities in the mural serve as a reminder of how far the area has progressed since early times, not only in politics but in commerce, transportation, and mail delivery as well.

The Artist

The artist was born in Gilby, North Dakota, on August 10, 1893,[10] and died January 17, 1954.[11] He was brought to Tennessee at an early age and worked as a teacher of

visual arts at Whitehaven High School during the years 1937 to 1946.[12] His professional background includes studies at the Art Institute of Chicago, the Art Students League, and the Society of Illustrators.[13] In addition to teaching, Mr. Fyfe also did advertisements and illustrations for nationally known magazines and later traveled and painted in Europe, Egypt, and the near east.[14] His other works for the Section of Fine Arts include murals for the United States Post Office in Magnolia, Mississippi.[15]

1. Rowan to Fyfe, July 29, 1937.
2. Fyfe to Rowan, October 31, 1937, Knoxville, Tennessee.
3. Fyfe to Rowan, October 27, 1938.
4. Rowan to Fyfe, July 29, 1937.
5. Biographical Document, *National Archives*, Washington, D.C., 1938.
6. Jonathan K.T. Smith, *Benton County* (Memphis, Tennessee: Memphis State University Press, 1979), p. 29.
7. Ibid., p. 31.
8. Ibid.
9. Ibid., p. 39.
10. Peter Hastings Falk, *Who Was Who in American Art* (Madison, Connecticut: Sound View Press, 1985), p. 220.
11. "Obituary," *New York Times*, January 17, 1954, p. 93, column 2.
12. Biographical Document, 1938.
13. Falk, p. 220.
14. Biographical Document, 1938.
15. Falk, p. 220.

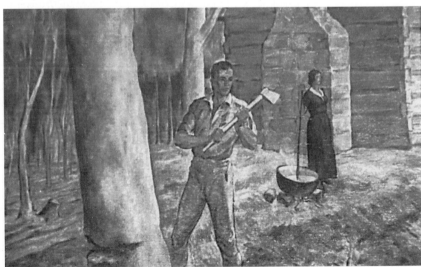

John Fyfe, *Mail Delivery to Tranquility—The First Post Office in Benton County* **(detail)**

John Fyfe, *Mail Delivery to Tranquility—The First Post Office in Benton County*

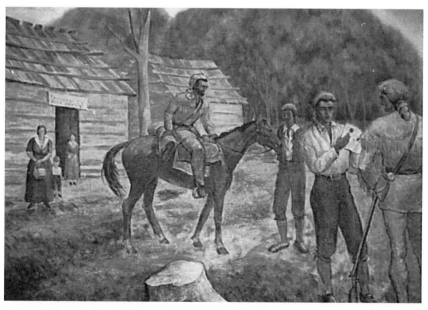

John Fyfe, *Mail Delivery to Tranquility—The First Post Office in Benton County* (detail)

CHATTANOOGA

The Chattanooga mural may be found in the federal courthouse in the middle of downtown Chattanooga. The large painting conforms to the curvature of the wall behind the judge's bench in an upstairs courtroom. Dimensions of the painting are seventeen feet three inches wide by five feet high.[1] The medium is oil on canvas, and it is entitled *Allegory of Chattanooga*.[2] It was painted by Mr. Hilton Leech of Sarasota, Florida, and installed in June 1937.[3]

The Description and Composition

This magnificent mural is a historical panorama of the people and events that are a part of the growth and makeup of the Chattanooga area. As our eyes move across the painting, each figure encountered is so complete and different from the others that it becomes a mini-painting within itself. At the extreme right bottom corner lies a dead soldier, his face already ashen in color. A white cross behind indicates the year of his death as 1863, the middle of the Civil War. Close to him, a nurse bandages the head of another soldier. Behind her, a woman prays as a missionary points heavenward. A fast-moving train leaves a trail of smoke. To the left of the soldier having his head bandaged, a railway worker wearing a typical engineer's cap drives a spike, and behind him a rebel soldier loads his musket. A young black man, in front of two Indians conversing with a frontiersman leaning on his rifle, fills a bag with cotton. A woman in the front center, dressed all in white and with the face of a madonna, cradles a small baby in her arms; and just to the left and back of her a pastor reads the Bible to a girl in a red dress.

To the left, an engineer scans a blueprint while his assistant surveys the land. A man and his wife, their knees in the fertile soil, set out tobacco plants while a woman wearing a bright red skirt indicates that she has brought a basket of food. In the distance, a farmer plows with a Tennessee mule, and far back is a Tennessee Valley

Authority dam providing electricity for lines overhead held up by towers of steel. Against the green hills farther back sits a rustic cabin, a symbol of hardy pioneer life. The picture is held together by the various people as they connect with or overlap each other. Even so, each figure, being engrossed in performing a particular act, seems somewhat isolated from the others. The various positions of the people provide a feeling of movement to the painting, counteracting the staticness usually associated with a formal composition. Each person occupies a space in time and in the memories of families long dead. The bright colors in the clothing set against a background of bluish mountains and white sky give a refreshing look to an otherwise staid courtroom.

The Mural's Relation to History

The mural relates to the history of Chattanooga and the Hamilton County area in an almost narrative manner. Distinctive time frames and activities are seen throughout the painting. The Indians shown probably represent the Cherokee Nation, a group friendly with whites for many years prior to the 1830s. They adopted many of the customs and practices that had been brought by immigrants from Europe, and soon became like the white man in various ways, including the attendance of religious services and the establishment of an alphabet. Unfortunately, Chattanooga is also where the infamous "Trail of Tears" began. On March 3, 1837, several flatboats were loaded with 466 Cherokees, and they were sent west. A second group soon started an overland trek.[4]

Chattanooga began with a small settlement of whites on a bend of the Tennessee River called Ross's Landing in 1815.[5] By 1839 that name had been changed to Chattanooga. Early settlers in the area were mostly subsistence farmers living on small plots of land where hard work from sunup until sundown was the general rule. By the 1850s, the railroad had reached Hamilton County, and the area became an important trade center. With movement by

steamboats and flatboats on the river, and the arrival of the Western & Atlantic and the Nashville & Chattanooga railway systems, passenger and business travel began to flourish.

During the early 1860s and throughout the duration of the Civil War, Chattanooga was an important military objective. Its strategic location made it vital to both the Union and the Confederacy. The battles of Missionary Ridge and Chickamauga were extremely bloody affairs. Hamilton County probably suffered more from the war than most other parts of Tennessee. The city was overwhelmed with wounded soldiers, refugees, and freed slaves. Food, medicine, and facilities were stretched to the limit.

When the war was over, Chattanooga, like the rest of the Southern states, started reconstruction with an eye toward future expansion of river and rail traffic. Mining and minerals became an important source of revenue. By the 1880s, streetcars were a common sight in the city. Other commercial ventures (such as the Coca-Cola Company, which began in 1899), new sources of electricity from river dams in the early 1900s, and finally the huge impact of TVA on recreation and industry have helped make the area the technologically advanced hub of activity that it is today.

The Artist

The artist was born October 13, 1906, in Sarasota, Florida.[6] His early training was in Bridgeport, Connecticut, at the Grand Central School of Art and at the Art Students League in New York.[7] He was also a pupil of the very famous American artist George Inness.[8] He was a painter and a teacher of art during most of his career. He held teaching positions at Ringling School of Art in Sarasota and at Arragansett Art School in New York.[9] Mr. Leech also painted a mural for the post office in Bay Minette, Alabama.[10]

1. Rowan to Leech, June 2, 1936.
2. Marlene Park & Gerald E. Markowitz, *Democratic Vistas: Post Offices and Public Art in*

the New Deal (Philadelphia: Temple University Press, 1984), p. 228.

3. Leech to Rowan, June 8, 1937, Nashville.

4. James W. Livingood, *Hamilton County* (Memphis, Tennessee: Memphis State University Press, 1981), p. 17.

5. Ibid.

6. Peter Hastings Falk, *Who Was Who in American Art* (Madison, Connecticut: Sound View Press, 1985), p. 365.

7. Ibid.

8. Biographical Document, *National Archives*, Washington, D.C., undated.

9. Falk, p. 365.

10. Park and Markowitz, p. 201.

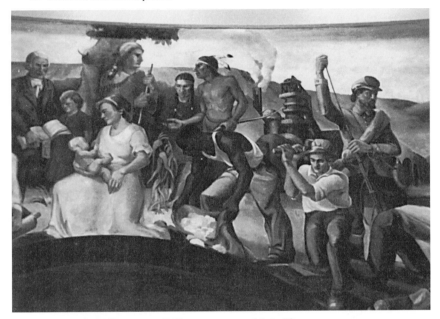

Hilton Leech, *Allegory of Chattanooga* **(detail)**

Hilton Leech, *Allegory of Chattanooga*

— 21 —

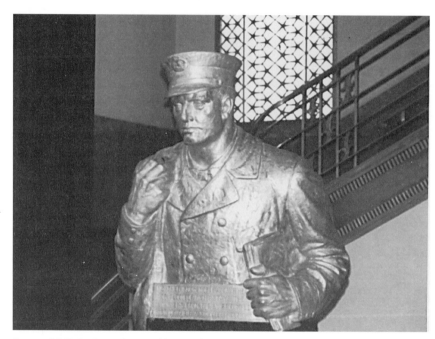

Leopold Scholz, *The Mail Carrier*

In addition to the mural, Chattanooga is also fortunate to have been the recipient of a large sculpture as part of the Federal Art Project. It is located at the end of the hall on the first floor and is a bust of a postman dressed in full regalia. The sculpture, mounted on a marble pedestal, was created by Mr. Leopold Scholz of Boiceville, New York.[1]

The Description and Composition

The sculpture is a solidly built, formally balanced, semi-triangular composition. Soft lines of the coat contrast with the muscular facial features, providing enough realism to make the figure believable. Both arms seem to be in a position of movement, with the right one securing a small mail pouch. There is a look of determination on the face that reminds us that the mail will be delivered no matter what the obstacles might be. With all of this in mind, it is easy to see that Leopold Scholz has created a sculpture that is the epitome of the dedicated mailman.

The sculpture was installed in the post office on November 28, 1938.[2] Including the pedestal, it is eight feet tall by two feet six inches square and made of cast aluminum.[3] At the bottom of the bust, one finds the famous statement by Herodotus: "Neither snow, nor rain, nor heat, nor gloom of night stays these couriers from the swift completion of their appointed rounds." It is a unique tribute to the people who carry our mail, and, positioned at the foot of the stairs, seems ready to answer any question from a postal patron.

The Mural's Relation to History

Historically speaking, the sculpture is a representation of the strong, sturdy, friendly mail carrier that many people have known and revered. He is large and muscular enough to carry any mail bag to either personal or business destinations. His uniform is typical of those worn by postal workers during the 1930s.

If we go back through history to the beginning of the Revolutionary War, when Benjamin Franklin was the first

postmaster general, and then retrace our steps to the present, we will encounter numerous types of postal wear, from the cowboy-style hat and six-gun worn by famous pony express rider W. F. Cody to the gray-blue jacket and pants of the 1990s. In between, there have been various items of attire worn by postal men and women, including blue shirts, gray shirts, white shirts, and shirts with high collars worn with a vest. There have been short coats, long coats, and medium coats; long pants and short pants; and an assortment of hats.

There have also been many methods of delivering the mail. Some of those are horseback, river steamer, flatboat, train, automobile, truck, bus, airplane, and even missile. It is a certainty, though, that however mail arrives, and whatever the person is wearing who brings it, be it the walking city letter carrier or the Rural Free Delivery System, what is really important is the mail itself. It is a form of communication between cities, nations, governments, and a multitude of agencies, and for most people the reading of it is an eagerly anticipated and pleasurable event.

The Artist

The sculptor was born in Boiceville, New York, in 1877 and died May 13, 1946.[4] He was married to a famous sculptor from Nashville, Belle Kinney. Together they collaborated on many works of art, including the restoration of the pediments of the Parthenon in Centennial Park; a bust of Maj. E. C. Lewis, director of the Nashville Centennial Exposition, who conceived the idea of erecting a replica of the Parthenon in Nashville; and the portrait busts of John Sevier and Andrew Jackson in the Statuary Hall of the capitol in Washington, D.C.[5] "Of special interest is the one of Jackson, as it is the only one that depicts him as he looked at the Battle of New Orleans when he was forty-seven years old."[6]

One of the most superb pieces of the two artists' work is the *Victory* in Pelham Parkway, New York City. The memorial to New York's World War I heroes stands 120 feet at the

base, encircled by long lines of carved marching soldiers that support a corinthian column topped by the heroic female figure of victory.[7] It is considered to be one of the tallest in the world. Mr. Scholz was also commissioned to create a stone carving as part of the mural program for the post office in Angola, New York.[8]

1. Scholz to Rowan, March 9, 1938, Boiceville, New York.
2. Rowan to Scholz, December 2, 1938.
3. Rowan to Scholz, June 12, 1937.
4. Peter Hastings Falk, *Who Was Who in American Art* (Madison, Connecticut: Sound View Press, 1985), p. 550.
5. Document, Tennessee Archives, Nashville, undated.
6. Ibid.
7. Ibid.
8. Marlene Park and Gerald E. Markowitz, *Democratic Vistas: Post Offices and Public Art in the New Deal* (Philadelphia: Temple University Press, 1984), p. 219.

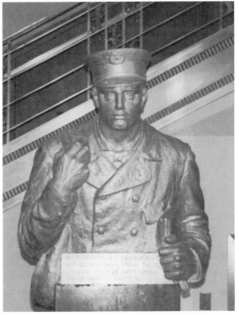

Leopold Scholz, *The Mail Carrier*

CLINTON

The city of Clinton is about twenty-five miles north of Knoxville. Hanging just inside the entrance of the new post office is a large mural painted by New York artist Horace Day. It was moved from the old post office in 1989. The mural, painted in casein tempera, is twelve feet by four feet ten inches.[1] This type of paint is more transparent than oil. The technique of using it produces a surface built of thin layers of color. The end result is a beautiful painting which seems very light and airy.

"R. A. (Bob) Smith, a former Clinton postmaster, said that he was working in the post office at the time the mural was painted and the postmaster at that time (1940) was the late E. C. Cross, who once owned the Clinton Hardware Company."[2] On June 12, 1940, Mr. Cross wrote a letter to the Federal Works Agency in Washington stating that the mural, entitled *Farm and Factory,* had been installed and that it had received favorable comments from the local citizenry.[3] He also said, "The mural is representative of the town and community. The colors are bright and attractive, and the impression made on the casual observer is good."[4]

The Description and Composition

The mural is characteristic of the Clinton area in the late 1930s.[5] The theme is the harmonious relationship between industry and agriculture. In the background, the low ranges of the Smokies are set against a sky of summer blue. Rolling through the center of the painting is a line of railroad cars filled with coal. In the foreground, workers walk with a light step, perhaps returning from the mill seen in the distance, while a man hauling hay waves to them as his shirtless helper loads with a pitchfork. On the left, a Plymouth makes its way up the slight grade, returning the driver home after a long day at work. In the far right of the picture, a red-haired woman carries water to other field workers. The sun shines brightly. The entire scene is like one of those remembered days when time seemed to move a

little slower.

In the distance, one can see what was purported to be the actual farm of the late W. E. (Al) Carden, father of Wade, Hazel, Marie, and Bernese Carden.[6] Miss Hazel Carden said that she thought the railroad tracks were closer to the bridge than they are in the picture and that the barn in the picture did not really exist.[7]

"The artist put the tracks and the farm where they are to add to the theme of the picture," she said. They also improve the composition of the picture. After all, one does not paint a farm or a bridge or a hay wagon. One paints a painting. Compositionally, the surface of the painting has a soft-brushed look reminiscent of work by the French Impressionist painter Renoir. The long, narrow format tends to lead the eye back and forth across the painting rather than around, as is the case in a squarish work. All major forms are either overlapped or touching, ensuring a unified connection within the picture plane. Finally, as a way to lend a natural look to the mural, colors are objective, from the sky tones to the faded blue of the bibbed overalls worn by the men carrying lunch buckets.

Horace Day, *Farm and Factory*

The Mural's Relation to History

The tower pointing skyward is that of the old Anderson County Courthouse, and the smokestack just to the right of it is the one for what was, at that time, the Magnet Mills building.[8] The structure supported by large concrete columns is the old bridge over the Clinch River.[9]

Clinton has always been the county seat for Anderson

County, but it has not always been called Clinton. Prior to acquiring its current name in 1809 (for De Witt Clinton, an early mayor of New York City), it was called Burrville after Aaron Burr, a one-time vice president of the United States.

Anderson, a rural county, has been an important farming area since its early days, producing large quantities of corn and tobacco; but the years between the 1870s and the turn of the century saw it become more oriented toward industrial development. With the aid of railroads, coal mining became extremely important. The Black Diamond Coal Company began operations during the 1870s and became a vital source of revenue for the county. Soon after, the infamous "company stores" where miners used scrip for purchases began to flourish.

The opening of the mines also precipitated a need for more housing for the workers and, consequently, the need for lumber to build with, and so another industry became important to the Clinton area. Logs were floated down the Clinch River to various destinations.

In 1905, the Magnet Mills, a facility that produced such wearing apparel as knitted socks, opened with a work force of thirty people.[10] By the 1950s, the workers numbered more than one thousand, indicating that business had been very good. It eventually closed in 1967.[11]

The TVA, and Norris Dam especially, has had a large impact on Anderson County. Recreation, agriculture, and commerce have all seen periods of growth from the 1930s, when TVA began, to the present. Each is an important part of the history of the Clinton area, and each relates to the mural in one way or another.

The Artist

After finishing the painting, Mr. Day said, "In painting the mural for the Clinton Post Office I chose as my theme, industry and agriculture. It is a progressive town, and the mural has tried to express the well being of this community, set as it is in a valley as lovely as any in the country."[12]

The artist was born in Amoy, China, in 1909 and

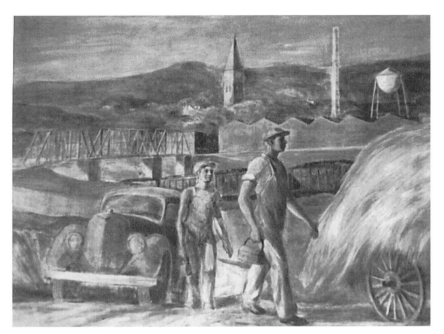

Horace Day, *Farm and Factory* **(detail)**

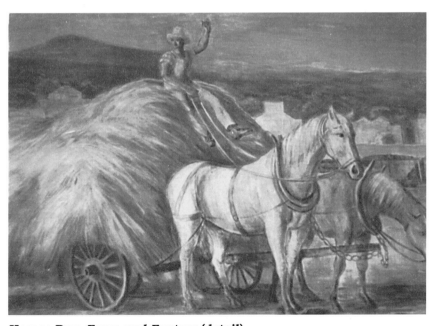

Horace Day, *Farm and Factory* **(detail)**

received his early training at the Art Students League in New York.[13] At the time he painted the mural, he was the director of the Herbert Art Institute in Augusta, Georgia, and later was employed as an associate professor of Art at Avery Baldwin College. His work is in many public and private collections, including those of Yale University and King College.[14]

1. Ed Rowan to Horace Day, August 1, 1939, Augusta, Georgia.

2. *Clinton Courier*, October 21, 1976.

3. E.C. Cross to Federal Works Agency, June 12, 1940, Clinton, Tennessee.

4. Ibid.

5. "New Mural for Clinton Post Office Shows Agriculture Industry Harmony," *Clinton Courier*, June 5, 1940.

6. "Farms and Industry United in Mural," Clinton Courier, October 21, 1976.

7. Ibid.

8. Ibid.

9. "Summer Reigns Forever in Mystery Painting," *Clinton Courier*, August 17, 1986.

10. Katherine B. Hoskins, *Anderson County* (Memphis, Tennessee: Memphis State University Press, 1979), p. 61.

11. Ibid.

12. *Clinton Courier*, June 5, 1940.

13. Peter Hastings Falk, *Who Was Who in American Art* (Madison, Connecticut: Sound View Press, 1985), p. 153.

14. Ibid.

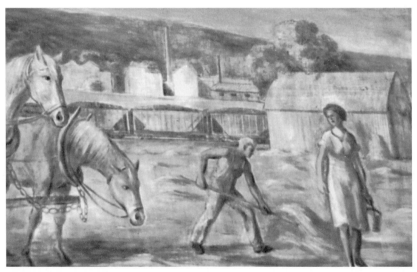

Horace Day, *Farm and Factory* (detail)

COLUMBIA

Columbia is about fifty miles straight south of Nashville in "Saturn Country," so-called because of its close proximity to Spring Hill, where the large Saturn automobile plant is located. The post office is a huge modern concrete structure in contrast to the small post offices where most of the murals are found.

Consequently, it is fitting that this oil on canvas painting is quite large and seems more grandiose than most of the others. Occupying a large portion of the right wall as one enters the building, the work, entitled *Maury County Landscape*, was installed during October 1942.[1]

The Description and Composition

The right side of the mural features a large tobacco barn. One can see the tobacco hanging inside. While two men wearing bibbed overalls and flat-topped hats converse just outside, a girl sits on the ground and ties up more leaves. One man sits on the mule-pulled wagon while the other leans against it. Neither the men nor the mule appear very energetic. Large green tobacco plants grow nearby.

Leading to a plant billowing smoke, a path of light is formed by the sun shining through a break in the clouds. Clumps of rounded trees recede into the distance. Left of center, a horse and its foal commune just inside the split-rail fence. A huge TVA power station is at far left, bringing electricity to the homes and businesses in the area. Though the scene is generally pastoral, the size and importance of the power station portends the coming of industry and change for Columbia.

The painting is beautifully done. Details of the tobacco plants are crisp and clear in shades of dark green. The deep panoramic space invites one to stop and enjoy the picturesque scene before moving on to other things. The serenity of the scene, however, belies the fact that there was considerable controversy before the work was completed.

There was some disagreement about the project. It was between the artist, Henry Billings of Rhinebeck, New York, and the architect, Bill Foster of Washington.[2] It seems that Mr. Foster wanted a border left around the mural whereas Mr. Billings did not.

In a letter to the artist, Mr. Ed Rowan stated: "I have again talked to the architect and explained that you as the painter did not concur with his opinion. He is unable to accept the kind of decoration that you are undertaking, going from wall to wall, either without a fadeout at the edges and a recall of wall color or without the border, is not a suitable solution for his building."[3]

Mr. Billings fired the following salvo back: "Frankly I find the architect's suggestions absurd, as well as delinquent. Tell him it is too late. I have already ordered the canvas and expect to go right ahead as fast as possible."[4]

At that point, the architect suggested that Mr. Billings be paid for the completion of the mural ($1,900) but that it not be installed. That did not work either. Eventually it was left up to Walter Meyers, the fourth assistant postmaster general, to make the decision. After considering the alternative, he finally authorized the installation of the huge seventeen feet three inches by six feet oil on canvas painting.[5] Compositionally, the painting functions much better without a border than it would have with one. The subject matter is representative of the area, and the structure is aesthetically pleasing.

The Mural's Relation to History

Records indicate that the first white settlers arrived in the area which is now Columbia, the seat of Maury County, in the early 1800s.[6] They came by flatboat, wagon, and horseback from North Carolina and East Tennessee, bringing livestock and a few slaves. They hunted the wild boar and deer for their skins and meat for the table and grew corn, cane, and other crops using farming methods that required hard manual labor.

By 1830, the population had grown considerably and the

raising of mules had become important to the local economy. Within twenty years the area would see an influx of hatters, tanners, saddlers, carpenters, shoemakers, blacksmiths, and tinkers. Maury County would become known as a place for "fat living," brought about by considerable profit making.[7]

The Maury County of today is still enjoying "fat living." From crops of tobacco, corn, and oats to the manufacture of automobiles, the economy, bolstered by electricity supplied by huge TVA dams, is thriving; and there are still mules around to remind us of the time when "Mule Day" was the high point of the year. It was held on the first Monday in April and was the largest street mule market in the world. Traders and visitors descended on Columbia from all parts of the United States until there were over ten thousand people filling the streets.[8] Shrewd buyers strode about talking business while others simply enjoyed the festivities. It was a rare occasion.

The Artist

Henry Billings, painter, lithographer, teacher, and mural painter, was born in New York City on July 13, 1901. His early art training was in the public schools of Bronxville, New York. He later studied at the Art Students League and eventually became a member of the National Society of Mural Painters, the Mural Artists Guild, and the American Society of Painters, Sculptors and Lithographers.[9]

His work has been exhibited in the Whitney Museum of American Art, the Museum of Science and Industry, and the National Art and Design Society.[10] He received commissions to paint murals for post offices in Medford, Massachusetts, and Wappinger Falls, New York, in addition to the one in Columbia.[11]

1. Dedman to Rowan, October 28, 1942, Columbia.
2. Rowan to Billings, February 25, 1942.
3. Rowan to Billings, February 10, 1942.
4. Billings to Rowan, January 2, 1941, Rhinebeck, New York.
5. Myers to Reynolds, December 2, 1941, Washington, D.C.

6. Jill K. Garrett, *Maury County, Tennessee, Historical Sketches* (Columbia, Tennessee: Self Published, 1967), p. 9.

7. Ibid., p. 274.

8. Ibid.

9. Peter Hastings Falk, *Who Was Who in American Art* (Madison, Connecticut: Sound View Press, 1985), p. 663.

10. Ibid.

11. Marlene Park and Gerald E. Markowitz, *Democratic Vistas: Post Offices and Public Art in the New Deal* (Philadelphia: Temple University Press, 1984), pp. 213, 221.

Henry Billings, *Maury County Landscape*

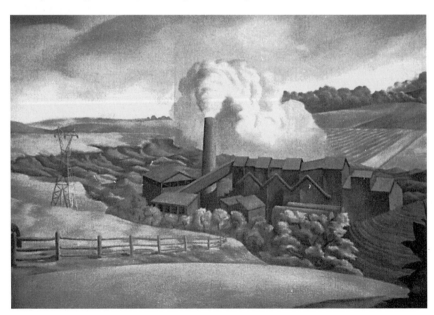

Henry Billings, *Maury County Landscape* (detail)

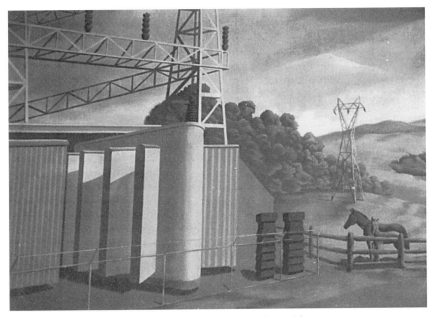

Henry Billings, *Maury County Landscape* (detail)

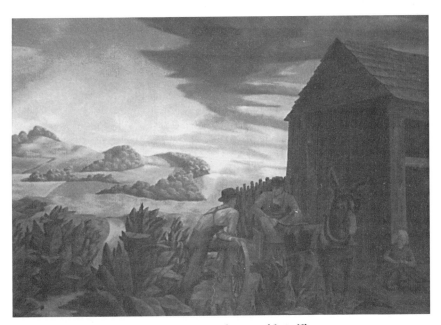

Henry Billings, *Maury County Landscape* (detail)

The large eagle on the front of the post office, near the top, is the work of Sidney Waugh, a noted sculptor from Amherst, Massachusetts.[1] It was installed in 1941.[2]

The Description and Composition

This massive concrete sculpture was cast from a clay model and is a stylized version of the national symbol for the United States. The bold, striking features of this great bird suggest a heroic nature. In its position on the building, it provides a focus of interest in the flat, gray surface surrounding it. With its claws extending over the front edge of the pedestal upon which it sits, its feathers forming a rhythmic pattern in the concrete, it appears as if the mighty wings are spread wide in an effort to envelope and protect all who enter.

The Mural's Relation to History

In 1782, the bald eagle was chosen as the national bird of the United States. Since that time, it has appeared in one form or another on various government documents and on coins and currency. It is a part of the uniforms of the armed forces and is used as a symbol on many federal buildings, including post offices. Different sizes and variations are found on these buildings. The eagle also covers most of the national seal. Its right claw holds an olive branch, indicating a desire for peace, while the left one grasps arrows, emblematic of the ability of the nation to defend itself.

While there are many types of eagles, only the golden eagle and the bald eagle are commonly found in the United States. Eagles are a relative of the hawk and possess the same grace in flight. They are also extremely powerful, very swift, and have extraordinary eyesight. It is an appropriate symbol for the postal services—especially air mail.

The Artist

Sidney Waugh was born January 17, 1904, in Amherst,

Massachusetts, and died in 1963.[3] He attended the public schools of Amherst and later studied in Europe. He returned to Amherst College, after which he entered the Architectural School of Massachusetts Institute of Technology. He received many awards, including medals from the Salon de Printemps in Paris and the American Prix de Rome.

The artist has exhibited in Paris, London, and New York

U.S. Post Office and Courthouse, Columbia

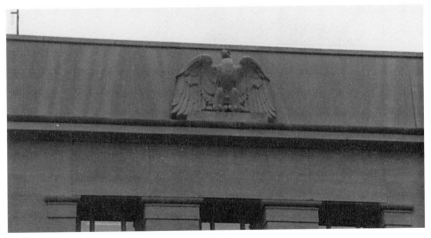

Sidney Waugh, *American Eagle* (detail)

and is represented in the Metropolitan Museum, New York; the Victoria and Albert Museum, London; and the collection of the king of Italy. His work can be found in other federal buildings, including the Federal Trade Commission Building, Washington, D.C., and the Buhl Planetarium, Pittsburgh, Pennsylvania. He is also the author of a book entitled *The Art of Glassmaking*.[4]

1. Peter Hastings Falk, *Who Was Who in American Art* (Madison, Connecticut: Sound View Press 1985), p. 663.

2. Marlene Park and Gerald E. Markowitz, *Democratic Vistas: Post Offices and Public Art in the New Deal* (Philadelphia: Temple University Press, 1984), p. 228.

3. Falk, p. 663.

4. Ibid.

CROSSVILLE

Crossville, a city just off I-40 about seventy-five miles west of Knoxville, has a mural painted by Marion Greenwood, an artist from Brooklyn, New York.[1] It was originally installed in the old post office on February 6, 1940,[2] but has recently been restored and moved to the new post office. The total amount paid to Miss Greenwood for creating the mural was $700. It is four feet high and thirteen feet wide.[3] The medium is oil on canvas, covered with a protective coating of varnish. The title is *The Partnership of Man and Nature.*[4]

Restoration of the mural has left the colors bright and vivid. Walking through the entrance to the post office is an exciting experience. When entering the door, one is surprised by this beautiful painting.

The Description and Composition

The composition of this mural is a series of contrasts. The color quality is natural, but even so, it has strong darks and lights throughout the work, producing a chiaroscuro effect that suggests a rounded three-dimensional quality to the figures, which, with their relaxed posture, are set against the rushing movement and angular structure of the concrete dam behind them. To the right and also behind the figures, the softness of recently plowed earth contrasts with the geometric construction of the red barn.

In a letter to Mr. Ed Powers, assistant chief of the Section of Fine Arts in Washington, Miss Greenwood said, "The mural suggests the conservation of water, forest, and soil. Man directs the turbulent current into a dam, from which the river flows out into a peaceful, fertile, Tennessee landscape. The harnessing and utilization of power is symbolized by the whirling dynamo and factory chimneys."[5]

The first idea for the mural was a bit different than the finished product. In many instances, the Section of Fine Arts requested the artists make significant changes from the original sketch before letting them complete the mural.

Artists tend to be a bit headstrong, and in certain cases they were reluctant to change. Often they were asked to move or eliminate entire groups of people, move buildings, add color, and other similar recommendations. Most artists did not agree but felt forced to accept the suggestions. It was as if the government wanted to make certain the art community knew who was in control.

The suggestions received by Marion Greenwood were not to her liking, as is shown by the following passages from a letter by her dated April 1, 1939: "I beg to disagree with the section about the central figure of the farmer being the least bit forced in position. I have the crayon drawing here. As I study it, any change in his posture would certainly be at the loss of the architectural rhythm necessary to all mural design." She goes on to say, "If the figure of the farmer did appear to me unnatural, I certainly would change it, but my aim throughout this design was especially that of a plastic restfulness, combined with understatement of gesture. The arrangement is the result of innumerable drawings experimenting with various structural designs for the given area."[6]

In the end, however, she was forced to change her original design to conform to the government suggestions.

The Mural's Relation to History

Crossville, in Cumberland County, was so named in 1856 because it was at the junction of the old Nashville-Knoxville Road and the Kentucky-Chattanooga Stock Road.[7] It was a very rough, primitive part of the country, settled by people from North Carolina and Virginia. They came to hunt and to enjoy the excitement of being free to pursue whatever future they desired. After the end of the Civil War, Union soldiers who had moved through the area came back to live in a place where the mild climate contrasted to that of the extreme northern states.

Like many other counties in East Tennessee, Cumberland was formed from a mix of surrounding counties. Parts of Morgan, Bledsoe, White, Roane, Putnam, Rhea, and

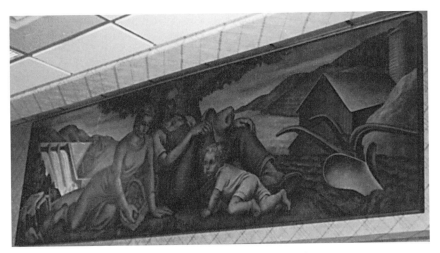

Marion Greenwood, *The Partnership of Man and Nature*

Fentress were put together to form Cumberland County.

During the years between 1870 and 1900, the economy changed from hunting and subsistence farming to the growing of such crops as potatoes, hay, and corn on large agricultural tracts for export to other counties and states. The lumbering industry became extremely important as large acreages of deciduous trees such as oak, maple, and walnut became cash crops. By 1909, Cumberland County had forty-four active sawmills turning the trees into building materials.[8] During the winter months, farmers earned extra money by cutting timber to be used as ties for the railroads extending into the mountainous area. Those railroads brought new people, and the people in turn established new businesses and began to use new farming methods and equipment. The trend extended into the 1930s with added impetus by the coming of TVA and rural electrification and continued into the 1980s, boosted again by the new interstate highway system.

The Artist

Marion Greenwood began her art career as a student at the famous Art Students League in New York. She was fifteen at the time. Studying with people like John Sloan,

Robert Henri, and George Bridgeman provided her with a foundation to become one of America's best known mural painters. By her early twenties, she had been to Paris and had become a legend in Mexico for murals painted in Morelia and Mexico City. While in Mexico, she was influenced by the famous muralists Diego Rivera and Jose Orozco.[9]

In 1936, Marion and her sister, Grace, also an artist, became involved in designing murals for a housing project in Camden, New Jersey.[10] The theme of the murals was collective bargaining related to achievements by the Camden shipyard workers. Like many other murals painted during the New Deal, those have been painted over.[11]

After completing the Crossville mural, Miss Greenwood continued her spectacular career as an easel painter and muralist. During World War II, she and Anne Poor, another mural painter, were the only two women hired as artist war correspondents. When the war ended, she began a series of paintings based on her travels to such places as Europe and the West Indies. She enjoyed painting the differences in people's faces and dress from various countries. She felt that race was not important and simply painted them as human beings.

In 1954, she was commissioned to paint a mural for the University of Tennessee at Knoxville. The mural is a jumble of musicians, both black and white, performing jazz, spirituals, country music, and folk dances. It is a lyrical mass of humanity involved in America's favorite pastimes. Unfortunately, it was later paneled over to prevent it from being damaged after some students called it racist. With her concern for all humanity, it is inconceivable that the work could be called racist.

Regarding her work, she said, "Over the years I have seen and painted them all on their home grounds: the Portuguese fisherwoman, the Haitian mother and child, the American teenager, and the women of Mexico and China."

Marion Greenwood's work can be found in public and private collections around the world, including the Metropolitan Museum of Art, Library of Congress, Tel Aviv Museum of Israel, Bibliotheque Nationale of Paris, Yale

Marion Greenwood, *The Partnership of Man and Nature* (detail)

Marion Greenwood, *The Partnership of Man and Nature* (detail)

University, Boston University, and University of San Nicolas Hidalgo in Mexico. She died in Woodstock, New York, in 1970.[12]

Perhaps her life can best be summed up by a quote from an article written for *American Artist* magazine in January 1948: "Marion Greenwood is a woman, but is not a member of the weaker sex. The story of her career makes the average male artist seem like a knit by the fire body."[13]

1. Charlotte Streifer Rubenstein, *American Women Artists: From Early Indian Times to the Present* (Boston and New York: G.K. Hall & Co., 1982), p. 218.
2. Ealand to Greenwood, February 8, 1940.
3. Ealand to Greenwood, March 1, 1939.
4. Ibid.
5. Greenwood to Powers, January 9, 1939, New York.
6. Greenwood to Powers, April 1, 1939.
7. Department of Conservation, Division of Information, *Tennessee: A Guide to the State* (New York: Hastings House, 1949), p. 442.
8. Helen Bullard and Joseph Marshall Krechniak, *Cumberland County's First Hundred Years* (Nashville, Tennessee: Williams Printing Company, 1956), p. 111.
9. Rubenstein, p. 218.
10. Ibid.
11. Sheila Hewitt, "Great Mural Hangs Quietly in Post Office," *Crossville Chronicle*, (date unavailable).
12. Ibid.
13. Harry Salpeter, "Marion Greenwood, An American Painter of Originality." *American Artist*, January 1948, p. 18.

Marion Greenwood, *The Partnership of Man and Nature* **(detail)**

DAYTON

Going south about forty miles on Highway 27 out of Rockwood will get one to Dayton. Aside from the usual fast-food establishments and small businesses as the town comes in view, things do not seem to have changed much in the last fifty years. It is still a quiet, peaceful, pleasant place to live or visit.

Inside the old post office, there is a large, colorful mural just above the entrance to the postmaster's office. It has been there since June 1939. As a part of the Federal Arts Program, it was painted by Mr. Bertram Hartman, an artist from New York City. It is an oil painting on canvas entitled *View From Johnson's Bluff.*[1]

The Description and Composition

As a composition the mural is predictable, but the elements are organized reasonably well. The mountains in the background present a horizontal linear look as they recede in rows, getting succeedingly lighter in value. Up front, in a somewhat monotonous fashion, pine trees cut the painting in sections, with each section having people who become a focal point, establishing a rhythm of color as one's eyes move across the landscape. Farms in the valley occupy a checkered space serving as a connecting agent between a row of green hills and the trees and people in the foreground. This method of establishing unity within the design is a bit unusual but functions adequately.

Mr. Hartman traveled to Dayton during September 1938 and made a watercolor painting from Johnson's Bluff overlooking a wide expanse of the Tennessee River Valley. About the area the artist said, "I don't know of many scenes so beautiful as this view of the Tennessee Valley, the hills, the river and rocks—all make a wonderful setting for a study of nature's beauty."[2] The full-size mural which was later made from the watercolor painting is filled with those things typical of a rural Tennessee landscape. In the distance we see a hazy view of the Smoky Mountains, while

Bertram Hartman, *View From Johnson's Bluff*

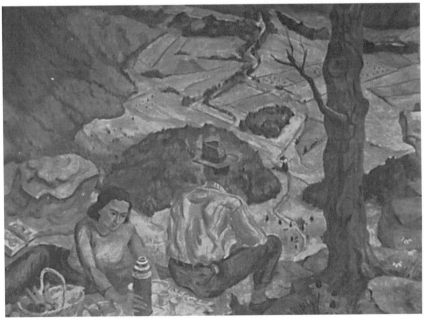

Bertram Hartman, *View From Johnson's Bluff* (detail)

the middle area shows farms and fields dotted by sections of green trees. Up close there are people at leisure. Some are busily eating or drinking, while others, along with their dogs, gaze upon the beautiful valley. A hawk flying overhead is echoed by one down below. Two redheaded woodpeckers search a pine tree for insects. Just to the left of the tree, a road winds through the valley separating the fertile farmland. All seems very peaceful.

The Mural's Relation to History

The mural was named for a place called Johnson's Bluff. It had once been a summer colony on the east section of Walden Ridge, a site offering a good view of the Great Smoky Mountains and Tennessee River.[3] Johnson's Bluff is in Rhea County, which was organized on January 25, 1808. The land had been bought from the Cherokees.[4] The original county was named Washington. It was an early settlement on the Tennessee River and enjoyed a time of prosperity brought about by the movement of river traffic. Dayton became the county seat in 1890.[5]

Early settlers came to the valley from Virginia, North and South Carolina, and other parts of Tennessee. They used the fertile soil to plant such crops as strawberries, peaches, grapes, and apples, many of which still grow in the area and are shipped to other parts of the United States.

Like other parts of East Tennessee, Dayton and Rhea County have benefited greatly from the TVA and its ability to bring electricity to outlying sections. Not only is the scenery quite beautiful, it is also a prime recreation area enjoyed by many.

The Artist

Bertram Hartman was born in 1882 and died in 1960 in Greenwich Village. He studied at the Art Institute of Chicago as well as abroad and is represented in the collections of the Metropolitan Museum of Art, the Whitney Museum of American Art, the Brooklyn Museum of Art, and Wichita Art Museum.[6]

Mr. Hartman preferred to be called a "creative" rather than "decorative" artist.[7] He said, "I react very definitely to the subject matter in front of me. One can never know too much, and the more one studies the world about one, the more he or she becomes conscious of the rhythms of nature. When one has not the sensitivity of the artist, one can think too much. Thinking alone never makes a work of art."[8]

The artist was part of a large family of eight children, including one sister, Rosella, who was also a gifted painter, and grew up in Junction City, Kansas, a long way from the centers of art.[9] As many people in the arts have done, he eventually made his way to New York, where he established a lasting reputation as an Expressionist painter.

1. Ed Rowan to Bertram Hartman, May 12, 1938, New York City.
2. "Dayton Scenery Beats Lookout Mountain Says Artist," *The Herald News*, June 13, 1939.
3. Department of Conservation, Division of Information, *Tennessee: A Guide to the State* (New York: Hastings House, 1947), p. 364.
4. T.J. Campbell, *Records of Rhea, A Condensed County History* (Dayton, Tennessee: Rhea Publishing Co., 1940), p. 1.
5. Ibid., p. 3.
6. "Unusual Dual Show," *Sunday Times-Democrat*, December 11, 1966.
7. Ibid.
8. Ibid.
9. Ibid.

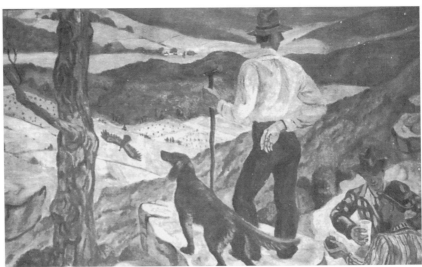

Bertram Hartman, *View From Johnson's Bluff* (detail)

DECHERD

Decherd has the distinction of being the smallest town in Tennessee to have had a mural commissioned for the post office. Located in the hilly country of the southeastern section of the state, it is a tiny, quiet place with a population of 2,196.[1]

It is one of the two cities in Tennessee (the other being Greeneville) to be the recipient of a post office mural in the form of a wood carving. At a cost of $750, the relief sculpture was completed and installed during the month of October 1940.[2]

It was carved by Mr. Enea Biafora of Warwick, New York. His energetic use of the chisel has produced a work that exudes vitality and a sense of purpose. The warmth of the wood provides an aesthetic oasis for one end of the small post office. Possibly because it is a relief rather than a painting, it seems to be more noticed and appreciated by postal patrons.

The Description and Composition

The high relief carving depicts a woodcutter as he pauses in his work at the noon hour. His pipe is a fixture in his right hand while a single-bladed axe held lightly with the left rests between his legs. The man's son, sitting just to his right, reads a letter received in the morning mail. All heads are turned toward the letter as the boy reads.

The work is carved with a chisel, with tool marks showing little refinement. That is fitting for the image of a woodsman, as it lends a feeling of strength to the sculpture. It has been carved from mahogany wood with all grain running in a horizontal direction, providing a stabilizing effect to counteract lines of the figures that move in many directions. The title of the four feet by five feet six inches sculpture is *News on the Job.*[3]

The Mural's Relation to History

Decherd, just down the road from Winchester, is located

in Franklin County, which was organized in 1807 and named for the American statesman Benjamin Franklin.[4] A typical southern village, it has a town square where local farmers sit under the shade trees in the summer and discuss the advantages and disadvantages of being involved in the dairy industry, for which the area is now noted. It is not far from Sewanee, where the old and respected University of the South is located.

Franklin, a "border" county just north of the Alabama line, was settled by hardy pioneers from North and South Carolina. Like many other Tennessee settlers, they lived on small plots of land and hunted and fished. This county is the one-time home of Davy Crockett, a famous hunter and, later, political figure who eventually met his death at the Alamo. His wife, the former Polly Findley, was buried in Franklin County, having died at a relatively young age while he was away fighting the Creek Indians in 1815 with Andrew Jackson.

From early times to the present, the land has always had large stands of hardwood. Woodcutters with their axes, crosscut saws, and now chain saws have worked in the area for decades, cutting and processing the oak, cherry, walnut, hickory, and maple trees that would eventually find their way into homes and businesses in Chattanooga and Nashville as furniture and lumber. The sculpture created by Mr. Biafora is a tribute to all of them.

The Artist

Although an American citizen for many years, Mr. Biafora was born in 1885 in San Giovanni-in-Fiore, Italy, where he received his early training. While he was still a boy, his father, also a sculptor, taught him the basic principles of design and techniques of using tools. He also studied at the Institute of Fine Arts in Naples.[5]

On coming to America, he continued his studies with George Grey Barnard, Paul Manship, and Melvina Hofman. Well known for his commissions for public building decorations for the federal government, as well as state and local

authorities, he has also embellished churches and many private buildings. One of his bronze sculptures, *The Centauress*, is in the permanent collection of the Metropolitan Museum of Art.[6] Other work may be found in public and private collections throughout the United States.

1. Decherd, Tennessee, *Rand McNally Commercial Atlas* (United States, Canada, and Mexico, 1993), p. 510.
2. R.M. Austin, Postmaster, to Insles A. Hopper, October 28, 1940, Decherd, Tennessee.
3. Biafora to Hopper, July 2, 1940, Warwick, New York.
4. Sophie and Paul Crane, *Tennessee Taproots* (Old Hickory, Tennessee: Earle-Shields Publishing Company, 1976), p. 31.
5. "Wood Carving Work of Art Decorates Decherd's New Post Office," *The Truth and Herald*, November 7, 1940.
6. Ibid.

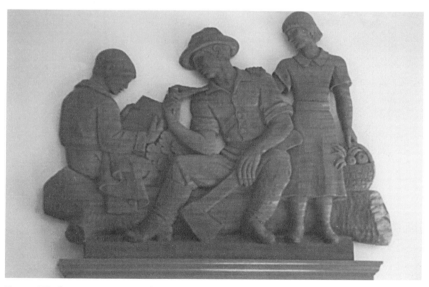

Enea Biafora, *News on the Job*

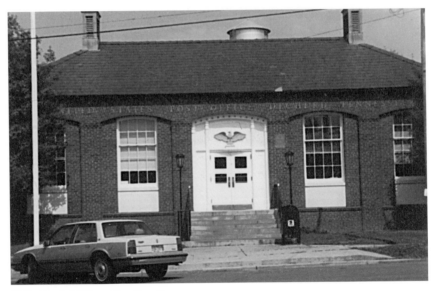

U.S. Post Office, Decherd

DICKSON

The mural in Dickson, just west of Nashville, is very unique. It is a fresco. Fresco is an Italian word meaning "fresh." It is a mural-painting technique using water-based paint on lime plaster. When doing this method of painting, the artist or his helper coats a section of wall where the mural will be painted with a layer of plaster mixed with lime. Only a section large enough for a day's painting is coated at one time. The artist paints on that damp section of plaster with pure pigments dispersed in water. As the surface dries, paint and plaster fuse together. After drying, fresco colors are bright and clear.[1]

Fresco is a very old painting method. Prior to the Italian Renaissance, it was used by the Minoans, Greeks, and Romans in the warm Mediterranean climate.[2] Perhaps the most well-known fresco ever painted is the ceiling of the Sistine Chapel in Rome, painted in the early 1500s by Michelangelo.

The Dickson mural, entitled *People of the Soil*, is ten feet wide by five feet high.[3] The on-site painting by Chicago artist Edwin Boyd Johnson was completed December 14, 1938.[4] In a letter to the Section of Fine Arts in Washington, Mr. Johnson said, "From all reports the mural is well liked, and I think that the people of Dickson know just a little more than they did before about fresco painting."[5]

In a telephone conversation on June 1, 1994, Mr. Don Battles, postmaster, stated that the mural was still on the wall in the old post office building but was not currently available for viewing by the public. However, he indicated that the portion of the building where the mural is located may become a contract postal station in the near future. In that event, the building would be open to the public.[6]

The Description and Composition

It is a fabulous painting. What an honor it is for Tennesseans to have been able to enjoy such a work of art for so many years. When looking at the painting, one sees

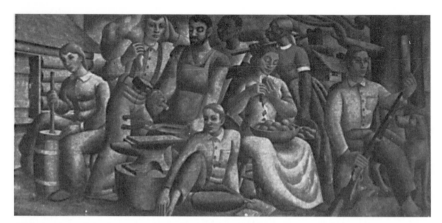

Edwin Boyd Johnson, *People of the Soil*

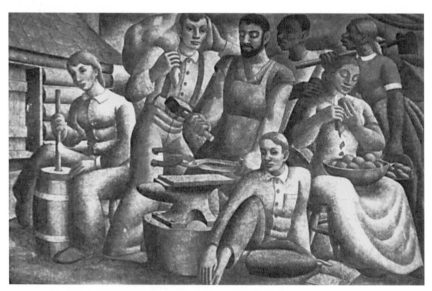

Edwin Boyd Johnson, *People of the Soil* (detail)

what appears to be a family group of mostly hard-working people. In the center section, the mother sits peeling potatoes while a helper brings up another bucketful. A son wearing suspenders stands with a bulging sack on his shoulder as if asking, "Where should I put these?" His muscular-armed father diligently works at the anvil, using hammer and tongs to create a horseshoe. In the vicinity of a log cabin at the far left, a girl sits churning butter. There are two other sons, both wearing shirts with collars buttoned tightly around their necks. One holds a gun as if he is almost ready to leave for the purpose of hunting game for the family table. A large hound waits impatiently. The boy in the middle foreground is perhaps the youngest son. He sits idle, as if daydreaming about events of another time.

The expressions on the faces of the people are neither happy nor sad. They seem resigned to completing the tasks at hand as they go about their work in a businesslike manner. The painting is beautifully done in a color scheme employing soft blues and blue purples complemented by the tans and browns interwoven throughout the composition. The exaggerated roundness of figure parts such as arms and legs is typical of fresco technique. The damp plaster facilitates the blending of the colors, making the tonal quality more evident.

The Mural's Relation to History

Considering the title of the painting, *People of the Soil*, and the subject matter used, there seems to be only a general relationship to the Dickson area. The clothes the people are wearing could indicate a time close to when the mural was painted. That would be in the 1930s. Both their dress and other objects in the work suggest a people close to the earth, but that scene is appropriate for many places in Tennessee. All agricultural families of this era seemed to accumulate instruments of survival such as the churn, anvil, and hoe. It was also common for Tennessee families to own guns and to keep hunting dogs. The two blacks in the rear probably represent two field hands employed to

Edwin Boyd Johnson, *People of the Soil* (detail)

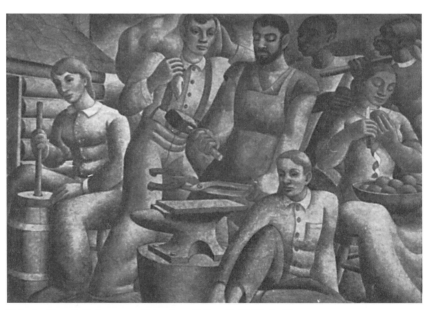

Edwin Boyd Johnson, *People of the Soil* (detail)

help with various farming tasks and may or may not live permanently with the family. Whether or not there is a direct relationship between the mural and Dickson does not really matter. The important thing is that the painting is beautiful; its design qualities and color harmonies far surpass any relationship to certain groups or localities.

The Artist

Edwin Boyd Johnson was born November 4, 1904, in Watertown, Tennessee, and grew up in Nashville, where he studied art at Watkins Institute. He is a graduate of the Art Institute of Chicago and studied at the National Academy of Design in New York City. Johnson received instructions in fresco painting at the Kunslgewerbeschule in Vienna, the Atelier de Fresque of Paris, and the Ecole Egyptienne des Beaux Arts in Alexandria, Egypt.[7] In addition to Dickson, he executed murals for post offices in Melrose Park and Tuscola, Illinois.[8] His work has been exhibited and collected worldwide.

1. *Dictionary of Artists and Art Terms* (New York: Random House, 1981), s.v. "fresco."
2. Ibid.
3. Rowan to Johnson, August 15, 1938.
4. Johnson to Rowan, January 3, 1939, Chicago, Illinois.
5. Ibid.
6. Telephone conversation with Don Battles, Postmaster, June 1, 1994.
7. "People of the Soil, Subject for Painting at Post Office," *The Dickson County Herald*, August 18, 1938.
8. Peter Hastings Falk, *Who Was Who in American Art* (Madison, Connecticut: Sound View Press, 1985), p. 316.

DRESDEN

The city of Dresden, in upper West Tennessee, has a beautiful mural painted by Minnetta Good, an artist from New York.[1] The large painting, an oil on canvas, is thirteen feet six inches by five feet ten inches. The title of the painting is *Retrospection*.[2] Its basic theme is concerned with the early days of Weakley County.

The mural was installed September 22, 1938.[3] The postmaster at that time was Mr. William H. Pritchett.[4] In a letter written to Ms. Maria K. Ealand, Administrative Assistant, Section of Painting and Sculpture, Washington, D.C., Mr. Pritchett said, "I am pleased to advise that the installation of the mural in the post office building has been completed by Miss Minnetta Good, and is entirely satisfactory.

"I would like to say that the mural is beautiful and very appropriate for this office. It is highly appreciated by the good people of this city, and we feel grateful to the Treasury Department for furnishing this office with such a wonderful painting."[5]

Another letter, from the Dresden Garden Club to Mr. Ed Rowan, said, "We the Dresden Garden Club, send you this message of appreciation of the mural in our new post office building. We prize it for its exquisite beauty, the splendid workmanship, and for what it means to us. It is, indeed, a wonderful picture that Miss Good has given us. And to you we are grateful for making this painting possible for us. It is such a beautiful and worthwhile cause you are sponsoring that we wish to express our appreciation both to you and of the picture."[6]

The Description and Composition

The mural is done in a different style than others in the state. Rather than showing a panoramic view of a particular landscape, it is broken up into several segments depicting people or things important to the early days of the area. In the top of the picture in the very center is the old courthouse as it looked prior to the addition of the wings, which

were added in 1913.[7] At the top left is a pioneer log house surrounded by a stand of lush trees. A tiny bear just to the left of the house meanders away in search of food. In the upper right corner, two workmen prepare the railroad bed for the coming of the train which, in the future, would be destined to replace the stagecoach shown below. Under the stagecoach, a group of people stand and chat, perhaps about the crops or dry weather. In the very center, above the mantel and flanked on the right and left by medallions representing Tennessee and the Weakley County Court, is a portrait of Robert Weakley.

In the far left center stands Davy Crockett wearing buckskins and leaning on a long rifle as he is menaced by a second bear in the picture. Below him, Andrew Jackson, who later became president of the United States, and Isaac Shelby discuss important documents with the Indians. In proximity to the Weakley portrait and the seals, one sees examples of corn, cotton, and tobacco, products which are still grown in Weakley County. Throughout the composition, areas of rich green color abound, giving the painting a cool, restful feeling, and there are just enough browns and tans present to lend some contrast to the work, providing enough excitement to keep it from growing stale as a composition.

The Mural's Relation to History

Dresden, a city named after Dresden, Germany, and settled by German emigrants, is located almost in the center of Weakley County, which gets its name from Robert Weakley, one of Tennessee's most well-known politicians. After some time spent in state government, he became a United States Senator and at one time ran unsuccessfully for governor.

The area that would become Weakley County was purchased from the Chickasaw Indians, with Andrew Jackson making the deal on October 9, 1818, for the sum of $300,000.[8] When the Fifteenth General Assembly met in Murfreesboro (then the state capital) on October 21, 1823, Weakley County was born.[9]

Minnetta Good, *Retrospection*

Minnetta Good, *Retrospection* **(detail)**

As the subject matter of the mural indicates, different modes of travel have always been important to the settlement and progress of the county. Early settlers came by various means, including wagons floated on rafts across the Tennessee River. Just getting to a settlement was hazardous. In the early days there were few roads, and many were little more than horse trails.

One notable resident, Davy Crockett, represented in the mural, arrived shortly after fighting in the Creek Indian War of 1813-1815. Born in the eastern part of the state, he gradually moved west, eventually stopping in the Weakley County area. While he was living there, he served several terms in the Tennessee legislature. After his defeat in 1835, he left for Texas, never to return to Tennessee.

The first crop grown in the area was corn, which was used to feed livestock and for making corn bread. During the middle 1800s, it became one of the largest corn-producing areas in the state. It still is. Much of the corn goes to feed the great number of hogs being raised by local farmers. A considerable amount of tobacco is also grown as a cash crop, and this, too, is shown in the mural.

The means of travel, however, is more important to the progress of Weakley County than agriculture or anything else. The flatboat, stage, and wagon travel of the 1820s, '30s, and '40s was a start, but it was very slow compared to the railroads, which arrived by 1860. The area then was provided with a direct line to Nashville. Produce could move out and raw building materials and new settlers could move in at a rapid pace. Soon, industries such as cigar and barrel stave factories, shoemakers, gristmills, and blacksmiths became numerous and prosperous. The county was well on its way to becoming a vital and growing part of Tennessee.

The Artist

Minnetta Good was born in New York in February 1895 and died May 21, 1946.[10] She studied at Cooper Union and New York School of Design for Women.[11] In 1920, she was a student at the Art Students League and studied with

Robert Henri, leader of the now famous "Ashcan School," and F. Luis Mora, who did the mural for the Clarksville Post Office, which is now destroyed.[12] She later worked in and exhibited lithography and paintings in major shows in New York and elsewhere, winning several medals at the National Association of Women Painters and Sculptors. She was also awarded a commission to execute a mural in St. Martinville, Louisiana.[13]

1. Rowan to Good, July 30, 1937.
2. Rowan to Good, November 15, 1937.
3. Pritchett to Ealand, September 24, 1938, Dresden, Tennessee.
4. Ibid.
5. Ibid.
6. The Dresden Garden Club to Rowan, October 17, 1938, Dresden, Tennessee.
7. "Mural Adorns Post Office Building," *The Dresden Enterprise*, 1938.
8. Virginia C. Vaughn, *Weakley County* (Memphis, Tennessee: Memphis State University Press, 1983), p. 8.
9. Ibid., p. 9.
10. Peter Hastings Falk, *Who Was Who in American Art* (Madison, Connecticut: Sound View Press, 1985), p. 221.
11. "Biographical Document," *National Archives*, Washington, D.C., undated.
12. Ibid.
13. Marlene Park and Gerald E. Markowitz, *Democratic Vistas: Post Offices and Public Art in the New Deal* (Philadelphia: Temple University Press, 1984), p. 169.

Minnetta Good, *Retrospection* (detail)

GLEASON

Gleason is a small town in the northwest section of the state. The post office mural—a tempera painting on canvas by Anne Poor, an artist from New York and the stepdaughter of Henry Varnum Poor, a noted artist in his own right— was installed October 23, 1942. It was one of the last post office murals to be completed in the state under the federally sponsored Section of Fine Arts Program.

The Description and Composition

The thirteen feet by five feet six inches painting, although a bit dark with age, is nevertheless a fine example of Ms. Poor's work. It is Impressionistic in style, with generally representational color. The painterly surface is an excellent vehicle for showing off the virtuosity of the artist's ability. Even though several things are taking place simultaneously, the painting seems to maintain a quiet feeling of unhurried activity.

The theme of the painting is the sweet potato industry of the region. Workers are preparing baskets for shipping. At the extreme right of the picture is a generalized portrait of the late "father" of sweet potato culture, Mr. W. R. Hawks.[1] The picturesque building in the background is the Gleason railroad depot.[2] The foreground of the picture shows several people involved in the packing of sweet potatoes and sweet potato plants. Children are looking on as their parents work, while other people are seen in various positions in the vicinity of the depot. On the right side, there seems to be some relationship between Mr. Hawks and a figure kneeling on the fresh, rich soil. Maybe he is passing on his store of wisdom to a younger person. As a final tribute to sweet potatoes, the entire painting is framed with a border of lush green leaves signaling a prosperity that will last long into the future.

Compositionally, the painting offers the viewer formal balance accentuated by the central placement of the railway depot with its slanting roof peaking at about the mid-

point of the painting. Great size differences between the figures in the foreground and the small ones in or near the doorway of the depot produce a strong illusion of three dimensional space while the repetition of figures across the canvas lend a rhythm kept from being monotonous by slight variations of size and placement.

The Mural's Relation to History

Gleason, in Weakley County, was incorporated in 1871. It had first been called Oakwood after a large oak tree that grew beside W. W. Gleason's general store.[3] Its development was centered near the tracks and depot of the Nashville & Northwestern Railroad. Part of a platform with a row of baskets filled with sweet potato plants is shown in the foreground of the mural. The baskets, sometimes called hampers, were made by the R. N. Nants veneering mill, which was in operation from 1916 through 1954.[4] Hampers were used to ship sweet potato plants in order for them to get air but still be protected.

Sweet potato plants were introduced into the Gleason area in 1913 by Mr. W. R. Hawks, shown in the mural. The industry grew in the succeeding years, and local growers prospered. Ten thousand bushels were grown and shipped per year.[5] At one time, one fourth of all sweet potatoes grown in Tennessee were grown in Weakley, Henry, and Gibson counties; and by 1944, Weakley County ranked fourteenth in national production.[6]

The famous "Nancy Hall" sweet potato had been named by R. N. Nants as he became the South's largest sweet potato shipper, prompting folks around the country to begin calling Gleason "Tatertown."[7]

The Artist

The painter of the mural was a very gifted artist. As a young woman, she benefited from an extremely talented and supportive family. Her mother, Bessie Brewer, married her second husband, Henry Varnum Poor, when Anne was seven years old. While growing up, Anne was encouraged

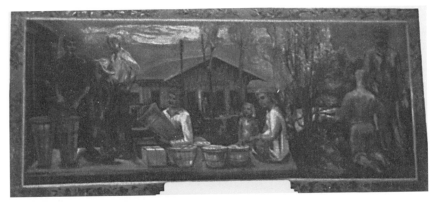

Anne Poor, *Gleason Agriculture*

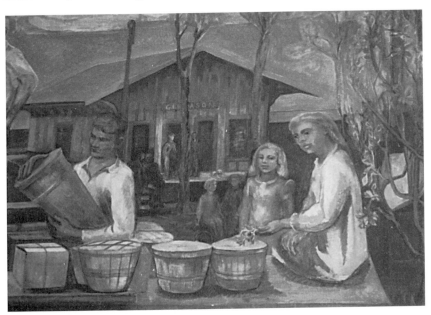

Anne Poor, *Gleason Agriculture* (detail)

by her stepfather to follow her dream of becoming an artist. As a young woman, she would paint beside him on mural projects for the Washington, D.C., area.[8]

As a teenager she attended the Art Students League in New York and later enrolled at Bennington College. In 1937, she went abroad for a year. While in Paris, she studied under the famous French tapestry designer Jean Lurcat.[9]

In 1943, she enlisted in the Women's Army Corps (WAC). During the war years, she was one of two women to serve as artist war correspondents. (The other was Marion Greenwood.) Regarding her appointment to that position, she said, "War is not pleasant, but if it is necessary, it should hit young women as well as young men."[10] She was extremely patriotic, and once told Charles Burchfield, the watercolor painter, she "had a constant gnawing impulse to be doing her part that gave her no rest."[11]

In retrospect, however, there were also more subtle reasons that motivated her. She said, "I felt that I had been living a cloistered life—attending private schools—always surrounded by high-powered people. I wanted to get to know ordinary people, and I wanted to know what the rest of the world was like."[12]

In 1944, her artistic depictions of war won her first prize in the National Army Arts Contest. In 1945, she was the only woman to exhibit at the National Gallery in Washington in a show of five U.S. Air Force painters.[13] After her discharge, she taught at the Skowhegan School of Art in Maine, which had been co-founded by her stepfather. In due course she became its director and trustee.[14]

In 1981, she won the Benjamin Altman Landscape Prize from the National Academy of Design for her oil painting *Ice on the River*. It was the second time she had captured the award, one of the many prizes, fellowships, and grants she has received in recognition of her ability as a painter and muralist. "Anne Poor has followed her personal vision, creating poetic realist paintings, which have found their way into the collections of numerous admirers."[15]

1. Sue Bridwell Beckham, *Depression Post Office Murals and Southern Culture: A Gentle Reconstruction* (Baton Rouge and London: Louisiana State University Press, 1989), p. 300.
2. Ibid.
3. Virginia C. Vaughn, *Weakley County* (Memphis, Tennessee: Memphis State University Press, 1983), p.64.
4. Ibid., p. 65.
5. Ibid., p. 66.
6. Ibid., p. 29.
7. Ibid., p. 66.
8. Penny Dunford, *A Biographical Dictionary of Women Artists in Europe and America Since 1850* (Philadelphia, Pennsylvania: University of Pennsylvania Press, 1989), p. 234.

9. Ibid.
10. Ibid.
11. Sylvia Moore, "Anne Poor," *Woman's Art Journal* Spring/Summer 1980, p. 50.
12. Ibid.
13. Ibid., p. 52.
14. Dunford, p. 234.
15. Moore, p. 53.

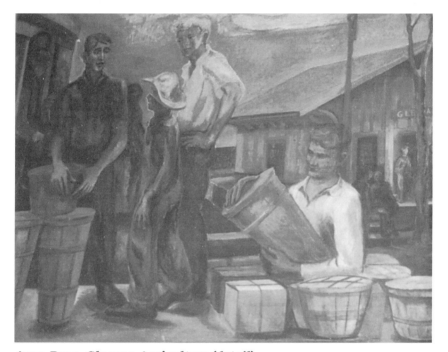

Anne Poor, *Gleason Agriculture* **(detail)**

GREENEVILLE

Greeneville, in the upper eastern section of the state, has the most valuable artwork created for Tennessee post offices. On the wall of an upstairs courtroom in what was originally the post office and courthouse building hang two magnificent relief sculptures carved from teak wood. Teak is a hard, yellowish-brown wood found in East India.[1] The murals were carved by William Zorach in Robinhood, Maine, and installed in the courthouse building on Saturday, March 9, 1940.[2] The pay from the federal government to the artist was $2,500.[3] According to Judge Thomas Hull of Greeneville, they are now valued somewhere in the neighborhood of $1 million.[4]

The Description and Composition

According to the artist, the two panels symbolize the forces that contributed most to the peaceful development of this country. Together they express the importance of the family and labor in this development. "The panel of the mother and child with the waterfall in the background symbolizes the natural power and resources of America. The panel of the man against the Norris Dam symbolizes man's effort and his development of the possibilities of this country and the tremendous projects which his brain conceives and his labor brings into being."[5] Each relief is three feet wide by seven feet high and approximately two inches thick.[6] They are entitled *The Resources of Nature* and *Man Power.*[7] Before arriving in Greeneville, they were shown at the prestigious Whitney Museum in New York.[8]

Both figures are carved in a sturdy rounded style symbolic of working people. The man, square jawed and shirtless, looks straight ahead, ready to complete whatever task he might encounter. The woman, cradling the child in her right arm, appears strong and robust while at the same time presenting the softness and appealing notion of eternal motherhood. The barefoot people in this low-relief sculpture are endowed with a stoic look, as if they have the

William Zorach,
Man Power

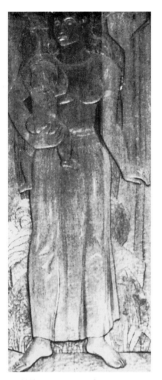

William Zorach,
The Resources of Nature

ability to surmount all unforeseen obstacles capable of impeding progress toward the fulfillment of their dreams. In the wood there are light and dark variations from tan to brown which add visual interest to the composition. Tool marks in the background, contrasting with the smoothness of the figures, do the same. It is a beautiful and enduring example of the art of William Zorach.

The Mural's Relation to History

This mural relates to the history of man and woman on a national level as well as to the people, both past and present, of Greeneville and Greene County. The importance of family, peace, progress, and labor was a feeling shared by early settlers in this area and is still relevant in today's world.

Greene County was founded in 1783 when Washington County, to the north, was divided. It was named for the

famous Revolutionary War hero Gen. Nathaniel Greene. Greeneville, the seat of Greene County, was the first capital of the State of Franklin, a section of present-day East Tennessee that broke from North Carolina in 1784. The State of Franklin lasted only four years as a political entity and then reverted back to the state of North Carolina.[9] In 1796, it and a large territory to the west became the state of Tennessee.

Greeneville was also the early home of Andrew Johnson, the seventeenth president of the United States, a former tailor and maker of men's suits.[10] Johnson was the governor of Tennessee from 1853 until 1857 and was instrumental in getting the first state tax passed that would directly benefit education.[11] He was later vice president under Abraham Lincoln, and in April 1865 became president upon Lincoln's assassination.[12] His term of office was not without strife. Shortly after the end of the Civil War, he very narrowly escaped impeachment as a result of his efforts to carry out Lincoln's program of generous treatment of the Confederate states. Although not formally educated, he was a man of honor and courage, which earned him a grudging respect from some political foes. He died of a stroke at age sixty-seven in 1875.

Greene County has always been predominantly agricultural, growing large amounts of burley tobacco from which cigars and plugs of chewing tobacco were processed in cigar plants during the early 1900s. It has also been important for its gristmills, sawmills, and woolen mills for the manufacture of sweaters, coats, and other garments. But more than anything else, the area is probably most noted for the patriotic figures that have lived and held important positions there. In addition to Johnson and Greene, there were John Sevier, fierce Indian fighter, governor of the State of Franklin, and first governor of Tennessee; and William Blount, who became governor of the Territory of the United States South of the River Ohio in 1790.

The Artist

William Zorach was born in 1887 and died 1966. He "was one of America's first artists to participate in the modern movement, to understand fully its aesthetics and to break completely with the traditional art of the academies."[13] He was born in Euberick, Lithuania, and was brought to the United States by his family in 1891.[14] His youth was spent near Cleveland, Ohio. His family, knowing nothing of art, insisted that he learn a trade. As a teenager he was apprenticed to a lithographer, and he returned to that trade at various times in his life. In 1905, at the age of eighteen, he went to New York to attend the National Academy of Design. In 1910, he went to Paris and subsequently enrolled at La Palette School, where he eventually met his wife-to-be, Marguerite Thompson.

While in Paris, Zorach was influenced by the exuberance of the experimental artists. He reveled in the pure color and simple shapes of the Fauves. He was excited by being in a city that loved art and artists. Both he and Marguerite became painters of abstract works. It was later that sculpture would become his main interest.

In 1911, he returned to America and resumed his lithographic work in Cleveland, Ohio.[15] The change was artistically deadening. Like most artists in that situation, Zorach tried to paint on weekends, but he found that arrangement unsatisfactory and left for New York in 1912. Marguerite met him there, and they were married soon after. Emotionally, his life became better, but financially that was not the case. In the first years of their marriage, he and Marguerite were very poor. Because no important gallery would show their work, they held small exhibitions in their studio. Sales were not encouraging.

After traveling to New Hampshire in the summer of 1917, Zorach made his first sculpture, and by 1922 he had abandoned painting altogether and had become a full-time woodcarver. His subjects were people in various poses and situations. They were executed in a much more representational style than his paintings. "He was inspired by

Egyptian, Persian, Greek art, and African woodcarvings."[16] In 1924, he was given his "first one-man show at the Kraushaar Galleries in New York; another came four years later, and the more-advanced cities and patrons became aware of a new art in their midst—an art that had its roots in America and was not merely a brilliant but temporary artist's sunburst like the Armory Show of 1913."[17]

From that point, his reputation as an accomplished sculptor began to grow. In 1931, the Whitney Museum in New York purchased *Pegasus*, a sculpture done in 1925.[18] From 1932 to 1935, he lectured on the history of sculpture at Columbia University, and from 1929 to 1960, he was an instructor at the Art Students League.[19]

In addition to being a creative sculptor, Zorach was also a writer. He published many articles for art periodicals and in 1947 published a book entitled *Zorach Explains Sculpture*.[20] He received many awards and honors during the latter part of his life. He had gone from a very outspoken abstract painter to a highly respected sculptor of a humanistic conservative style. In a reflective mood, he said of his life's work, "There are visions imprisoned in the rock or wood and the visions in one's soul—the things one does in seeking the inner rhythms of nature and life, in the journeys into an unknown region where one can grasp only mystic fragments from the great subconscious that surrounds us. There is much of pain and exultation in creative work. A relentless power that makes one create. This is my search." He died in Bath, Maine, at the age of eighty.[21]

1. *Webster's New World Dictionary* (New York: The World Publishing Company, 1956), s.v. "Teak."
2. Lindsay to Hopper, March 11, 1940, Greeneville, Tennessee.
3. Ealand to W. Zorach, May 10, 1939.
4. Interview with Judge Thomas Hull, November 29, 1991, Greeneville, Tennessee.
5. W. Zorach to Rowan, March 20, 1940, Brooklyn, New York.
6. W. Zorach to Rowan, March 12, 1939.
7. Ibid.
8. W. Zorach to Harper, October 10, 1939, Brooklyn, New York.
9. Department of Conservation, Division of Information, *Tennessee: A Guide to the State* (New York: Hastings House, 1949), p. 297.
10. Ibid.

11. Ibid., p. 298.

12. Ibid.

13. Wayne Craven, *Sculpture in America* (Newark: University of Delaware Press, 1984), p. 576.

14. Claude Marks, *World Artists 1950-1980* (New York: H.W. Wilson Company, 1984), p. 909.

15. Ibid., p. 910.

16. Ibid., p. 911.

17. Craven, p. 577.

18. Ibid.

19. Marks, p. 911.

20. Marks, p. 912.

21. Ibid.

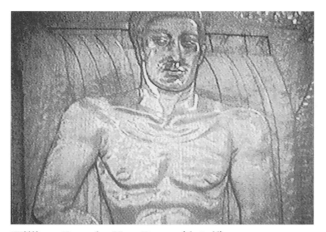

William Zorach, *Man Power* (detail)

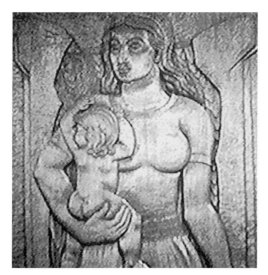

William Zorach. *The Resources of Nature* (detail)

— 73 —

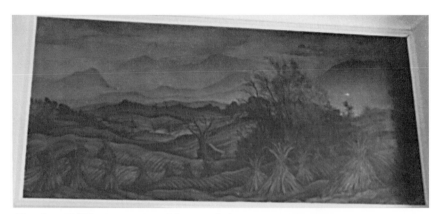

Charles Child, *Great Smokies and Tennessee Farms*

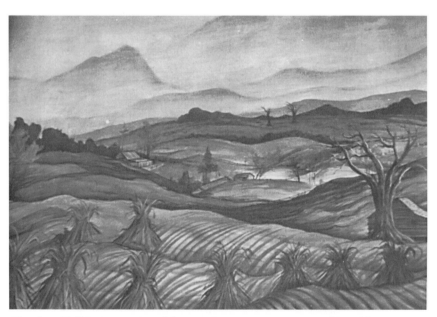

Charles Child, *Great Smokies and Tennessee Farms* (detail)

JEFFERSON CITY

Jefferson City is about a thirty-minute drive northeast from Knoxville. The mural in the old post office was painted by Charles Child of Lumberville, Pennsylvania.[1] It is an oil painting on canvas measuring twelve feet by five feet six inches.[2] The title is *Great Smokies and Tennessee Farms.* This picture, a fine landscape, was installed May 5, 1941.[3]

The Description and Composition

The painting is a late autumn scene showing a succession of rounded striated fields moving back toward a low range of hills in front of a panoramic view of the Smoky Mountains partially shrouded in early morning fog. Blue tips of the mountains reach up and softly touch a cold November sky. In the center of the composition, a cabin built of sturdy logs hides behind a leafless oak tree whose limbs reach out in an animated gesture reminiscent of a Charles Burchfield work.

Mountains and fields undulate gracefully, providing a rhythmic repetition broken by a lone tree here and there. A small lake almost hidden in a valley breaks the picture plane, its reflected light matching that of the sky. Yellow shocks of fodder occupy the front of the picture and march back through fields toward the right center and a clump of trees with a few green leaves still clinging to them. The clump functions as an area of emphasis, helping to stabilize the design features. The artist has presented an accurate depiction of the fertile, rolling land forms of Jefferson County. It is a pleasant, peaceful scene, greatly enhancing the visual appeal of the post office.

The Mural's Relation to History

Jefferson County, home of Jefferson City, was named for Thomas Jefferson, the third president of the United States. It was formed in 1792 from parts of Greene and Hawkins counties by order of Territorial Governor William Blount.

Pioneers, attracted by the fertile farmland, began arriv-

ing in the area as early as 1783 and immediately started growing such crops as corn, oats, and tobacco. Fields of wild strawberries were prevalent, and, to some extent, one can still find them in particular places today. Tame strawberries and peaches are also grown throughout the county during the summer season.

While the area around Jefferson City is generally known for its farmers and stockmen, who make up a large part of the population, there have been others whose famous footsteps have trod the county roads and walked through the doors of one or more of the well-known taverns found there in the late 1700s and early 1800s. Most notorious of all was the Dandridge Tavern, where such public figures as Andrew Jackson and John Sevier stopped from time to time to imbibe and talk politics with the locals.

In those days, a tavern was much more than it is today. In reality, it was an inn where travelers stayed the night, much as they do in the motels now. Of course, prices were considerably different. Breakfast and supper were nine cents each, dinner ten cents, lodging six cents, and a half pint of whiskey six cents.[4]

Fortunately, Jefferson County and the surrounding area are now known more for the many modern churches and stately homes built during the last hundred years. However, in his desire to place emphasis on what was most important to the citizens of the area, the creator of the mural painted the soil and what grows in it. In the eyes of many, that is correct. The land and the pleasures of planting and harvesting will always be there.

The Artist

Mr. Child was born in Montclair, New Jersey, on January 15, 1902.[5] Due to the early death of his father, his life as a young boy was filled with times of struggle and near poverty. During this time, he worked at a great many jobs, including farming, lumbering, ditch digging, and factory work.[6] He eventually attended Harvard University for a period of two years but quit in dissatisfaction. While at

Harvard, he was editor of the satiristic *Lampoon.*[7]

After leaving Harvard, he made his way to Europe, where he experimented with various art media and techniques such as fresco, tempera, oil, gouache, casein, and lacquers. During all of this time, he had virtually no formal instruction. While at Harvard, he had been assisted by friends in fresco technique and drawing theory. From time to time, he had also exchanged information with various Hindu and Chinese artists.[8]

As a mature artist in the 1930s, Mr. Child held respectable positions as a book illustrator and silk screen designer. He was also commissioned by the government to paint a mural for the United States Post Office in Doylestown, Pennsylvania.[9] His portraits and landscape drawings are in many public and private collections.

1. Ed Rowan to Charles Child, October 10, 1940, Lumberville, Pennsylvania.
2. Rowan to Child, January 10, 1941.
3. Rowan to Child, May 6, 1941.
4. Emma Trent and Deane Smith, *East Tennessee's Lore of Yesteryear* (Kingsport: Arcata Graphics, 1987), p. 209.
5. "Biographical Document," *National Archives*, Washington, D.C., no date.
6. Ibid.
7. Ibid.
8. Ibid.
9. Child to Rowan, April 25, 1944.

JOHNSON CITY

Johnson City is in extreme upper East Tennessee and has a beautiful post office mural painted by Woodstock, New York, artist Wendell Jones.[1] The large oil on canvas painting was originally installed in the old Johnson City Post Office on September 9, 1940.[2] It has since been removed and now hangs above the entrance to the auditorium in the D. P. Culp Center on the East Tennessee State University campus. It has been restored to its original color and intensity and is a wonderful addition to the Culp Center.

An interesting sidelight to the Johnson City mural is that during the time the artist was there, Eleanor Roosevelt also visited the area. It was Decoration Day of 1939, and she intended to visit the Veterans Hospital.[3] In a column printed in the Johnson City newspaper, she wrote about the view from her train window, mentioning such things as clothes hanging on a wash line, open doors to homes, people plowing, children, and water being transported by buckets.[4] She was not only a kind and compassionate person, she was also an astute observer and recorder of the human condition.

The Description and Composition

The principal subject of the mural is part of a train on the East Tennessee & Western North Carolina Railroad. For many years, it brought mail to the people of the mountainous area. Other elements of the painting are important to both the overall composition and the meaning of the work. In the foreground there is a farmer's truck with an open door. Inside the truck, a woman holds a baby, as a man, perhaps her husband, reaches to touch it. A quilt spills out of the passenger's side as another farmer, wearing a light-colored hat, opens his mouth as if to speak. Inside the truck bed are several cows held in by a rope being secured by a young man near a seated dog. A man directly behind the truck, and partially obscured by a pussy willow bush,

reads the daily news and gestures to another drinking from a cup.

In the rear of the picture we see the engineer leaning out of the window of the cab while a workman unloads lumber and adds it to the stock in the rear. In the upper right corner, smoke is blown from a burning pile of brush where new ground is being cleared for planting. It is a scene filled with simultaneous activity, yet held together with the repetition of similar colors and shapes as people emerge from different parts of the painting.

Although the color system is a bit subdued, the value contrasts and emphasis of line from the rope on the truck and the lumber being carried, as well as edges of various shapes going in a multitude of directions, makes the painting literally sparkle with movement. It is appropriately named *Farmer Family*.

The Mural's Relation to History

Johnson City became the principal city in Washington County shortly after 1865. Several railway lines had begun to service the area in the late 1850s, and the number increased toward the end of the Civil War. Prominent

Wendell Jones, *Farmer Family*

among these were the East Tennessee & Virginia and the East Tennessee & Western North Carolina. The ET&WNC was a narrow gauge railroad that used steam locomotives with high pitched whistles. Because of this, the natives gave it the nickname "Tweetsie." Crews on a train going in one direction filled shopping orders and gave the goods to the crew going the other direction for delivery. At times they even took care of kids paying a visit to grandma.

These trains were instrumental in opening up isolated areas for people who otherwise would have had little contact with the outside world. Three lines converged in the center of town, making it a junction. These lines became extremely vital to the industries as the county began to grow economically. Those early industries included box factories, tanneries, lumber yards and lumber mills, a foundry, and machine works. During the late 1800s, the growth of the area continued, and by the early 1900s, with the coming of the automobile and eventually electricity, acceleration was noticeable in many fields as gasoline pumps, garages, and hard-surfaced roads became necessary to support the automobile.

Johnson City also became agriculturally important with its livestock and tobacco markets. Cattle, sheep, chickens, and pigs were processed and shipped to cities in East Tennessee and other parts of the United States. By the mid 1940s, TVA had become the distributor of electricity for the area, and primitive living conditions improved greatly. People in rural sections of the county purchased refrigerators and electric washers. Tractors replaced horses and mules, and small farms became large farms as more acreage could be tilled in the same amount of time. The twentieth century had arrived in Washington County.

The Artist
Wendell Jones was born October 25, 1889, in Galena, Kansas.[5] He was a graduate of Dartmouth College and studied at the Art Students League in New York.[6] He also studied with the renowned mural painter Kenneth Hayes

Wendell Jones, *Farmer Family* (detail)

Wendell Jones, *Farmer Family* (detail)

Miller and worked for a year as an assistant to another mural painter, Hildreth Meire.[7] In addition to Johnson City, he painted three other post office murals. In all of these, he "painted with an informality and interest in detail that marks them as American Scene Works. In every case, he stressed the sense of community—people coming together to raise a barn in Rome, New York; to settle a town in Greenville, Ohio; and to save the city from flood in Cairo, Illinois."[8] In an article written for the October 1940 issue of *Magazine of Art*, he said:

> Mural painting seems to me to give the opportunity to paint symphonically, a range of great scope being possible on one surface. The building itself is the frame and the surface, and only the epic seems worthy of such dimensions. The building itself is part of the life of the community. The painting, therefore, must be contemporary and rise out of the spiritual reservoir of that community.[9]

1. Shell to Rowan, October 23, 1940, Elizabethton, Tennessee.
2. Postmaster (unreadable signature) to Rowan, September 18, 1940, Johnson City, Tennessee.
3. Rowan to Jones, June 12, 1939.
4. Document from National Archives file, undated.
5. Peter Hastings Falk, *Who Was Who in American Art* (Madison, Connecticut: Sound View Press, 1985), p. 321.
6. "Biographical File," *National Archives*, Washington, D.C., 1940.
7. Ibid.
8. Marlene Park and Gerald E. Markowitz, *Democratic Vistas: Post Offices and Public Art in the New Deal* (Philadelphia: Temple University Press, 1984), pp. 139, 140.
9. Wendell Jones, "Article of Faith," *Magazine of Art*, 33 (October, 1940), p. 554-559.

LA FOLLETTE

In 1939, the town of La Follette had a population of only 2,637 people.[1] Nevertheless, the federal government commissioned a mural to be painted for the small post office. La Follette, located off I-75 about forty-five miles north of Knoxville, has been described in various terms from picturesque to drab. The post office is located in the older part of town and is much as it was fifty years ago.

The mural, an oil on canvas, was painted by Dahlov Ipcar, daughter of Marguerite and William Zorach, each of whom painted a mural in other cities in Tennessee.

Before beginning the painting in her studio, the artist drove to La Follette and talked to people in the area.[2] She made four different sketches showing various aspects of the surrounding countryside. One was an early historical scene of the 1800s, one represented a Civil War battle, and the other two were scenes on the shore of Norris Lake.[3] Obviously one of the lake scenes became the choice.

As the mural neared completion, there was some concern on the part of the postmaster, Ms. Irene Miller, as to how it would be installed. Most were glued to the plaster wall using a mixture of white lead and varnish. (The ones that have recently been restored posed a danger to the person removing them from the wall. Special precautions had to be taken.) Ms. Miller requested that the mural be attached to a wood frame for easy removal from the wall. She was concerned that dampness from the wall would damage the painting. The federal government did not concur, and the mural was installed in the usual manner by Mr. A. J. Bamberg of Knoxville.[4]

As of the summer of 1995, the mural was not in good condition. There was some cracking in the lower left corner and some peeling paint, and in general the colors had darkened considerably. Still, it is apparent that at one time the subtle colors of soft browns and blue-greens of nature would have been a wonderful tonic to someone coming in to take care of postal matters.

The mural is entitled *On the Shores of the Lake* and depicts a hunter and two fishermen in natural surroundings. It is twelve feet four inches long by five feet nine inches high and located on the wall to the left of the entrance.

The Description and Composition

Just to the right of center in this Expressionistic painting, an early morning angler shows off a good-sized largemouth bass while his fishing buddy, wearing a hat and wading boots, busies himself with a stringer of smaller fish. A sturdy johnboat can be seen behind the man holding the bass. On the far left, a hunter in a vest holds a straining hound. A large oak tree provides shade. In the distance, mist rises from the clear water of the lake.

The time of year appears to be late October. Brown leaves cling to the oak tree, but smaller green leaves are still visible near its base. Much of the color in the painting consists of neutral grays, including those in the sky, ground, and tree trunk. These are strengthened by the tans and browns of the clothing worn by the men. With the exception of the crisp lines of the white, black, and brown of the dog, who looks much too slender and leggy to be a typical hunting hound and is positioned somewhat awkwardly, the colors are very soft edged. Pictorially, the blue-green lake and whiteness of the mist above it act as a frame around the two central figures, outlining them in the bright morning light.

The Mural's Relation to History

The city of La Follette in Campbell County was incorporated in 1897. Campbell County itself was established in 1806. Sitting at the eastern base of the Cumberland Mountains, the county is known primarily for two activities: coal mining (including strip mining) and recreation, enhanced by Norris Lake, which was formed in 1936 when the Tennessee Valley Authority impounded the waters of the Clinch River.

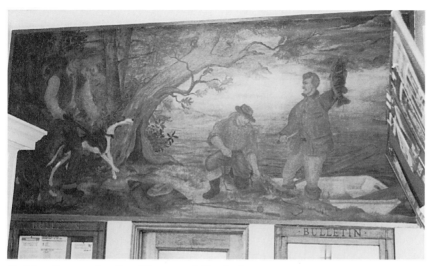

Dahlov Ipcar, *On the Shores of the Lake*

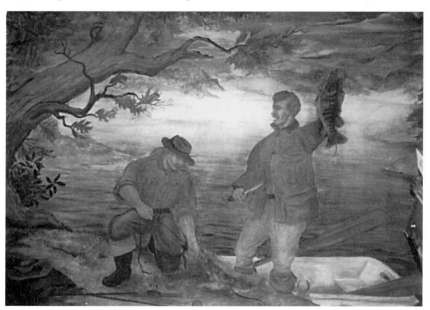

Dahlov Ipcar, *On the Shores of the Lake* (detail)

Coal mining has been prevalent in Campbell County since before the twentieth century began, and in 1897 the county was an important center of the coking industry. Ovens could be seen burning brightly during the night. In 1912, 1,802,413 tons of coal were mined in and around the

La Follette area.[5]

Recreational activities on the lake include fishing (as shown in the mural), swimming, pleasure boating, and water skiing. Various types of fish, from crappie to bass, may be found in the cold, deep waters of the lake. Its clear water and tree-lined shore are valuable resources enjoyed by the people of the Volunteer state.

Like many other rural areas in Tennessee, Campbell County was originally settled by hunters and farmers. They came from North Carolina and Virginia, cleared land, and started farming. The number grew, and by 1850 there were 481 small farms and the population was 5,750, including 97 "free colored" persons and 318 slaves.[6] Also listed among the population were one doctor, three lawyers, eight school teachers, and five merchants.[7]

The Artist

The artist was born November 12, 1917, in Windsor, Vermont.[8] Dahlov Ipcar attended Oberlin College but received most of her instruction from her parents. She was well respected as a professional artist, and exhibited in galleries throughout the United States, including the Museum of Modern Art in New York. She also was commissioned to paint a mural in Yukon, Oklahoma. Her work is in many collections, including the Whitney and the Metropolitan museums.[9]

1. "Mural for Tennessee Post Office by Dahlov Ipcar of Robinhood," *The Bath Independent*, September 15, 1939.

2. Ipcar to Rowan, September 25, 1938, Robinhood, Maine.

3. Ibid., November 7, 1938.

4. Ibid., August 24, 1938, La Follette.

5. Patricia Barton, Jim Stokely, and Jeff O. Johnson, eds., *An Encyclopedia of East Tennessee* (Oak Ridge, Tennessee: Children's Museum of Oak Ridge), p. 80.

6. Ibid., p. 79.

7. Ibid.

8. Peter Hastings Falk, *Who Was Who in American Art* (Madison, Connecticut: Sound View Press, 1985), p. 246.

9. Ibid.

LENOIR CITY

The small post office in Lenoir City is about like it was more than fifty years ago. It sits just to the right of Highway 11 in the center of town. The red brick facade and the eagle over the entrance are as they have been since World War II. Inside, and high on the wall to the right of the window where postal business is carried on, is a mural entitled *Electrification.*[1] It is a casein tempera on canvas painting by David Stone Martin. The dimensions are four feet five and a quarter inches by eleven feet ten and a half inches.[2]

The mural is in a special category all by itself in that it is a part of the "Forty-Eight States Competition" sponsored by the federal government in 1939. Only one city was selected from each of the forty-eight states. The painting was installed in the post office on August 3, 1940.[3] It, along with each of the other winners in the "Forty-Eight States Competition," was reproduced in the December 4, 1939, issue of *Life* magazine.[4]

After the installation of the mural, the citizenry celebrated in the form of a banquet for the artist and his wife, sponsored by the Rotary Club.[5] However pleased they were with the mural, they were not pleased with the *Federal Writers Project* guide to Tennessee in announcing that Lenoir City had been designated the winner. The guide saw fit to include only eight lines about the city.[6] There is not even one line giving directions about how to get there.

The Description and Composition

The painting shows workers putting up power lines that will bring electric lights to the Tennessee Valley. Large poles being used to support the lines recede into space on a backward trek. "In the foreground, the scale of these supports and of the project to electrify the valley is clearly indicated as a workman prepares to set in motion the process that will raise a single structure many times his height."[7] Far to the rear, another man operates a winch as a part of the effort to raise the large structure while his partner in

the left foreground handles the rope.

In the right foreground, two workmen are busily putting together a transformer. On the far left, a man wearing the paraphernalia of a climber gestures aloft with a gloved hand. Just in front of the low hills of the distant Smokies, a boy dressed in bibbed overalls and his mother carry water for the workers. On the ground is the standard galvanized bucket. The woman holds a water pitcher.

The overall impressions of the mural is one of men judiciously going about the job for which they were hired. The imagery showing the experience of putting up a power line is accurate and well thought out. The predominance of a light grayish green palette is pleasing to the eye as one glances up while otherwise occupied at the postal window.

The Mural's Relation to History

The title of the mural, *Electrification*, reflects the Rural Electrification Administration's (REA) efforts to transform the Tennessee Valley, including Loudon County, from a somewhat primitive area into one in which every person would have access to those things which electricity could provide.

The REA was established in 1935 under President Franklin D. Roosevelt. In the middle of the Depression years, less than eleven percent of every hundred homes had electricity.[8] "The REA began with a ten-year electrification loan program, with loans being made primarily to cooperatives at two percent interest for thirty-five years. In 1944 it was extended indefinitely."[9]

The program not only improved agriculture and farming methods, it made living conditions better for the everyday person on the street. In addition, it brought industries into the county, made possible the ownership of telephones, radios, electric freezers, and, beginning in the 1950s, television. With the help of the TVA, it indeed transformed the valley.

Loudon County was established in 1870 and named in honor of Fort Loudoun, an army post built by the British in

1756. A restoration project at the site has been going on for several years.

Early crops grown by farmers in the region were hay and grains, such as corn, which was ground in the gristmills by a miller after he exacted a toll from the customer, ensuring himself a business profit. Another crop grown in the area was ginseng, a root highly prized by the Chinese for its medicinal and supposedly aphrodisiacal properties. The plant also grows wild in the mountains of Appalachia and has been dug and sold to export merchants for shipping to Asia for many years.

One of the early industries of note was the Lenoir Car Works, a plant where railroad cars were built and repaired. It began in 1904. By 1907, it covered thirty-three acres, and during WWI it reached a peak of twenty-seven hundred employees. It continued operation as a viable enterprise through WWII and into the 1950s, gradually declining in number of workers until the 1980s, when less than twenty were left assembling glued joint rails and producing brass Journal bearings.[10]

The Artist

David Stone Martin was born June 13, 1910, in Chicago, Illinois.[11] Except for high school art classes, he was generally self-taught. At the age of twenty-three, he began work in Chicago as a graphic designer. In the early 1940s he held the position of art director in the War Information Office in New York, and by 1944 was named art director for the Disc Company of America.[12]

As a working artist, he became one of America's most prominent illustrators. David Stone Martin contributed to many major magazines and newspapers in the United States, created over four hundred record album covers, and designed innumerable billboards, title drawings, posters, and advertisements for motion pictures, television programs, and theatrical productions. In many ways he helped shape the image of America.

He painted cover portraits of Robert Kennedy, Eugene

McCarthy, Mao Tse Tung, and George Wallace for *Time* magazine. His series of posters and the symbol for the "Jazz at the Philharmonic" concerts and his illustrations for novels such as James Michener's *Caravans* are collector's items.

He has drawn album covers for the greatest musicians of jazz: Count Basie, Coleman Hawkins, Lester Young, Billie Holiday, Oscar Peterson, Dizzy Gillespie, Mary Lou Williams, Buddy Rich, Ella Fitzgerald, John Coltrane, and Miles Davis. In the process, he established an aesthetic standard for the depiction of jazz music.

All of Martin's drawings are characterized by the combination of fine and heavy ink lines which accentuate his particular shapes, volumes, and textures. So distinctive is his style that this line is known as the "DSM" line.

He has earned many distinguished awards from the Society of Illustrators and the Art Directors Clubs of New York, Boston, and Detroit. He was honored at the opening of *Time* magazine's grand exhibition celebrating its fiftieth anniversary.

His work has been collected by the Museum of Modern Art and the Metropolitan Museum in New York, the Art Institute of Chicago, and the Smithsonian Institution in Washington, D.C. His work may also be found in galleries, corporate collections, and private collections throughout the United States.

1. Sue Bridwell Beckham, *Depression Post Office Murals and Southern Culture: A Gentle Reconstruction* (Baton Rouge and London: Louisiana State University Press, 1989), p. 306.
2. Ealand to Martin, November 1, 1939.
3. Galloway to Rowan, November 11, 1941, Lenoir City.
4. "Speaking of Pictures...This is Mural America for Rural Americans," *Life*, December 4, 1939, pp. 11-17.
5. Beckham, p. 306.
6. Ibid., p. 306.
7. Ibid.
8. *The World Book Encyclopedia*, 1980, XVI, 483.
9. Ibid.
10. Patricia Barton, Jim Stokely, and Jeff O. Johnson, eds., *An Encyclopedia of East Tennessee* (Oak Ridge, Tennessee: Children's Museum of Oak Ridge), p. 286.
11. Biographical Document from National Archives, Washington, D.C., undated.
12. David Stone Martin, *Who's Who in Graphic Art* (Zurich: Amstutz & Herdeg Graphics Press, 1962), p. 520.

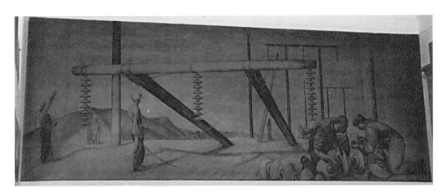

David Stone Martin, *Electrification*

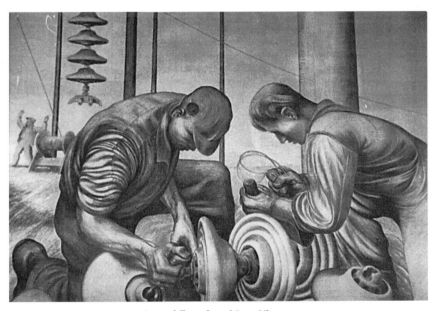

David Stone Martin, *Electrification* (detail)

LEWISBURG

Columbia, Mount Pleasant, and Lewisburg are all about fifty-plus miles south of Nashville, and all very close to each other. Each also has a post office mural. The one in Lewisburg was painted by John H. R. Pickett of Richmond, Virginia.[1] It measures ten feet by six feet and is an oil on canvas entitled *Coming 'Round the Mountain.*[2] It was originally placed in the old post office on October 5, 1938.[3] It was later removed, restored, and is now installed in the outer lobby of the new facility.

In a letter to Ed Rowan of Washington, D.C., Mr. Pickett said, "I have probably given this mural more time than necessary, but I wanted particularly to do a creditable job in Tennessee, which as you remember is my birthplace."[4] The artist chose the subject matter for the painting in an endeavor to "capture the spirit of the migration of the early settlers from North Carolina over the Cumberland Pass and around the mountains into Middle Tennessee."[5]

The Description and Composition

The mural is a symphony of strong dark and light contrasts, with only a small amount of warm color added to particular objects, such as the largest covered wagon and the steer in the center foreground. The forms of the wagon, people, and animals are defined by heavy black lines, increasing the feeling of solidity and strength.

Taking inventory of the subject matter, one sees at the lower left section a long-eared dog staring solemnly ahead. Behind it is the first in a line of ox-drawn wagons. A man with his arms extended strains at the wheel in an attempt to move it forward, while another, dressed in buckskins, keeps the oxen moving. The head of a woman and a child is framed by the opening in the first wagon, and on the right a shepherd on horseback drives the family sheep. In the background, depicting another method of pioneer travel, is a flatboat making its way down a winding stream while two men operate the "sweep." The horizon is seen as an irregu-

lar line of small, treeless hills looking as if the wind has swept them clean of all vegetation, producing an almost surreal look to the picture. Despite the lack of color, the subjects seem very believable. The multitude of dark lines serves as a device that ties each part of the painting together into a single unit. The end result is a strong, forceful painting.

The Mural's Relation to History

Marshall County was settled primarily by veterans of the Revolutionary War who had received land grants from the federal government as bonuses for having served. Most came from North and South Carolina to settle in the fertile land of Middle Tennessee. They came by foot, wagon train, horseback, and flatboat, wearing the deerskin clothing they had become accustomed to in the mountainous country where they had fought the Indians and the British.

They brought with them breeding stock that would be the ancestors of the large Jersey herds that became the

John H. R. Pickett, *Coming 'Round the Mountain* **(details)**

mainstay of the dairy industry there today. Horses would also be traded and bred to eventually become the fine harness racers and beautiful Tennessee Walkers that are found in all sections of Middle Tennessee, including Lewisburg.

Historically, Lewisburg is famous for being the city in which James K. Polk worked prior to becoming president of the United States in 1845. He practiced law in both Columbia and Lewisburg, and had offices in the latter. He was the eleventh president and a somewhat unpopular one. Social reformers regarded him as a tool for slave owners, and the general public did not like his personality. He was cold and taciturn and seldom smiled. He served as governor of Tennessee from 1839 to 1841, and as president from 1845 to 1849. He did not seek reelection, and shortly after leaving office he contracted cholera and died.

The Artist

John H. R. Pickett was born in Memphis in 1896. He was the son of A. B. Pickett, founder of the Memphis *Scimitar*. His training as an artist began at the Art Students League in New York. He also studied art education in the Navy during WWI when stationed in Turkey and was an instructor of anatomy and life drawing at the Richmond, Virginia, division of William and Mary College during the early 1930s. A member of the Richmond Academy of Fine Arts and Sciences and the Virginia Museum,[6] he was commissioned to paint a mural for the post office in Virginia Beach.[7]

1. Supervising Architect (name missing) to Postmaster, October 22, 1937, Lewisburg, Tennessee.
2. Fine Arts Section to Pickett, December 10, 1937.
3. S.E. Prossen, Postmaster, to Rowan, October 5, 1938, Lewisburg, Tennessee.
4. Pickett to Rowan, July 26, 1938, Lewisburg, Tennessee.
5. Ibid.
6. Document from the General Services Administration of the United States Government, Washington, D.C. (undated).
7. Marlene Park and Gerald E. Markowitz, *Democratic Vistas: Post Offices and Public Art in the New Deal* (Philadelphia: Temple University Press, 1984), p. 231.

LEXINGTON

Lexington, a small city south of I-40 and east of Jackson, has a splendid mural painted by Grace Greenwood of New York. The oil on canvas entitled *Progress of Power* is thirteen feet wide by four feet high.[1] According to Mr. Sam C. Jones, postmaster at that time, it was installed on January 27, 1940.[2]

"The mural was well received in Lexington. An excerpt from a local newspaper said, 'Lexington is the proud possessor of a beautiful mural. It should afford the people of the section much enjoyment and is interesting enough to keep fine arts alive.'"[3]

A postal clerk was also pleased with the mural. Mr. Henry B. Davenport wrote to Mr. Ed Bruce of the Section of Fine Arts in Washington and said, "Allow me to take this opportunity to express my thanks and appreciation for the fine mural painted by Miss Grace Greenwood of New York City, and installed in the lobby of our post office building by Mr. James Giangrasso. The mural has caused a great deal of interest around here, and we have received many nice compliments from the general public. I am a post office clerk here and many local citizens call at my window and ask about the mural. I describe it to the best of my ability, and it seems that it is being well-liked by the people of this community, especially these civic-minded citizens who appreciate the finer things in life.

"I had the pleasure of assisting Mr. Giangrasso in installing the mural, and my association with him has caused me to believe that he is a high class gentleman and well trained in his work. Since I am an amateur photographer, I took several pictures of the mural and I am sure that copies of them have been sent to your office. Again, let me say thank you. With best regards for your continued success in the installation of fine arts in our public buildings."[4]

The Description and Composition
The mural was painted in a very precise style. Objects

are clean and crisp, bringing to mind the industrial forms of another American painter, Charles Sheeler. All images emphasize a strong three-dimensional quality. Edges are so clearly defined that some seem almost Cubistically angular.

Colors are fresh and vibrant with enough value contrasts to make the rounded figures appear natural. Motion is evident throughout the picture. The train moves, the propeller turns, the man throws the switch and electricity flows.

The subject matter symbolizes modern industrial development through the generation of power from natural resources, resulting in advantages to both man and animal as well as giving man the chance for cultural improvement. These advantages are symbolized by the turbine, the streamlined train, and the transmission of power.

On the left is part of a horse and broken wheel, a depiction of the old order which is being gradually eliminated. In the very center, dressed in white, is a figure which separates the images symbolizing the evolution of power. Behind and to the right of the figure is part of an airplane, suggesting a change in the way mail is delivered. At right of center is a person dressed in a brown shirt about to throw a switch that will activate the power. All is painted very slick and modern looking without a brushstroke in sight.

The Mural's Relation to History

Early inhabitants in Henderson County were Indians, primarily Chickasaws and Cherokees. The first white settlers came from Middle and East Tennessee and North Carolina. The city of Lexington was founded in 1822.[5] Their first cotton gin was built in 1823.[6] By the 1840s, cotton was king in Henderson County.[7]

As the population increased, economic progress continued. Roads and transportation improved and industries proliferated. The area became a very large producer of ceramic pottery due to excellent clay soil. Dishes, churns, crocks, and pitchers were made and sold.[8]

Railroad construction began in the county in the late

1880s, and soon afterward farm products were transported by rail. In addition to cotton, crops included corn, beans, onions, potatoes, and cabbages. By the 1930s, tractors and other modern equipment used in farming had replaced horses and mules. The 1930s also brought electricity to rural areas as a result of the TVA. Things could be done faster, creating a need for more employees, again adding to economic growth.

Grace Greenwood, *Progress of Power*

The first automobile had arrived in 1909.[9] By the 1920s the trucking industry had replaced the railroads as the primary freight and produce carrier. By 1934, Greyhound had been granted a franchise to run its buses through Lexington.[10] Just as the artist has symbolized in the mural, changes in technology and improvements in industry and transportation brought about by the evolution of electric power changed a slow-moving horse and carriage society into a dynamic, rapidly moving one. That is the *Progress of Power.*

The Artist

After the painting was completed and installed, the artist sent an interesting note to Washington regarding funding for the project. In a moment of frustration she wrote, "Could you hasten the $300 payment? This soybean diet is getting monotonous—to say the least!"[11]

Grace Greenwood is the sister of Marion Greenwood,

who painted the mural for the Crossville Post Office. She was born January 15, 1905, in Brooklyn, New York, and was a member of the Mural Painters Society, United American Artists, and American Artist Congress. Among her many works are fresco murals for Morelia and Mexico City, Mexico.[12]

1. Rowan to Grace Greenwood, January 4, 1939.
2. Jones to Federal Works Agency, February 2, 1940, Lexington, Tennessee.
3. Grace Greenwood to Rowan, February 5, 1940, Lexington, Tennessee.
4. Davenport to Rowan, February 19, 1940, Lexington, Tennessee.
5. G. Tillman Stewart, *Henderson County* (Memphis Tennessee: Memphis State University Press, 1979), p. 17.
6. Ibid., p. 27.
7. Ibid., p. 25.
8. Ibid., p. 29.
9. Ibid., p. 70.
10. Ibid., p. 92.
11. Grace Greenwood to Rowan, February 5, 1940.
12. Peter Hastings Falk, *Who Was Who in American Art* (Madison, Connecticut: Sound View Press, 1985), p. 246.

Grace Greenwood, *Progress of Power* (detail)

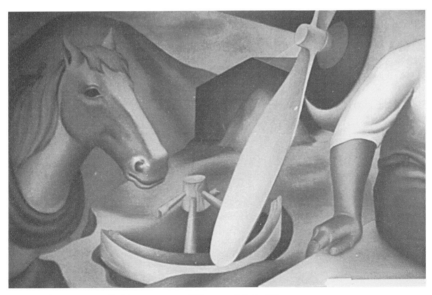

Grace Greenwood, *Progress of Power* (detail)

LIVINGSTON

Livingston is a delightfully rustic small town in the rolling hills just north of Cookeville. Around the town square, people go about their business in an unhurried manner and with a friendly smile. Just off the square in a bustling old post office hangs a large mural titled *The Newcomers*. It has been there since May 1940.[1]

The mural was painted by Margaret Covey Chisholm, a portrait painter from Pelham Manor, New York.[2] Its installation was very exciting. Even the artist's mother played a role. She sat for a period of time listening to what the people said about the artwork and wrote it down. In general it was considered to be "mighty purty" and harmonious with its surroundings. A janitor mentioned the coonskin cap. Other people thought the animals were well done, and the high school principal liked the overall color system.[3] The mural as it looks today seems to have endured well enough. Colors are still light and refreshing, and the subject matter is just as suitable as it was in 1940. In rural Tennessee, people still enjoy their farm animals and they still welcome newcomers with enthusiasm.

The Description and Composition

The mural covers the entire wall above the postmaster's door, with painted leaves extending down on both sides of it. The artist used as subject matter a young pioneer family of four, shown in the left section of the painting. The woman, wearing a homespun dress with a pattern of green checks, churns while the husband waves to the welcoming committee bringing with them things which will be needed for the family's survival.[4] Those things include some geese, chickens, two hogs, a sack of staples, and a basket of vegetables. Green leaves on the branch sticking out from behind the cabin indicate that it is the summer season. The cow appears ready to graze on scrubby grass in the center of the picture.

The mural is done in a narrative style characterized by

the placement of five adults and three children interacting with each other. Colors are natural, from the light tan cow to the buckskin shirts of the men. All figures on both sides touch or overlap, forming a unity of design as well as a unity of purpose. The cow and calf in the middle tie both halves together.

The Mural's Relation to History

Cabin raising is a very old tradition and most beneficial

Margaret Covey Chisholm, *The Newcomers*

Margaret Covey Chisholm, *The Newcomers* **(detail)**

to someone new to the territory. In most instances, settlers arrived with little in the way of material goods and were most fortunate for the kindness shown to them. After the cabin was raised and the newcomers were in it, every family near at hand brought in something to give them a start. "A pair of pigs, a cow and calf, a pair of all the domestic fowl—any supplies of the necessities of life which they had—all were brought and presented to the beginners."[5]

"All these acts of kindness were not only gratuitous, but were performed cordially and without ostentation. The strangers so appreciated them that on the first occasion that presented itself, they were ready with like spirit to extend similar kind offers to immigrants who came next. The offers thus became a usage and characteristic of the frontier stage of society."[6]

Livingston was named for Edgar Livingston, President Andrew Jackson's secretary of state.[7] Pioneers of Overton County (established 1806) lived a simple and sometimes harsh life. They grew crops on small farms, with women working alongside the men, hunted in the autumn, and trapped for animal skins during the winter months. They cooked in fireplaces using blackened iron pots. They ate beans, cabbage, potatoes, and bacon from the razorback hogs that were allowed to run wild in the forest. The hogs' ears were marked by the owners, and the animals were rounded up in November when the weather became cool enough to kill and process them. Ear marks were generally respected, but every now and then a feud would break out similar to the famous Hatfield-McCoy affair in West Virginia and Kentucky.

Each family usually had one or more cows, and each raised a small vegetable garden which grew beets, onions, tomatoes, and gourds, which had multiple uses, including ladles and dippers. They wore rough, homespun clothing and lived in relatively small cabins constructed from the trees in the area. Life was hard, but the cabin raisings made it bearable. It provided a sort of "working holiday."

The Artist

The artist, Margaret Covey Chisholm (mural signed Margaret Covey), the daughter of Arthur Covey, a well-known artist himself, began her art study at the age of fifteen at the Art Students League in New York City. She also studied at the Pennsylvania Academy of Art, spent a year at the Fontainebleu, France, Art School, and eventually received her Bachelor of Fine Arts degree from Yale University.[8] Her work is in many public and private collections.

1. Rowan to Custodian, United States Agriculture and Post Office Building, Livingston, Tennessee, June 1, 1940.

2. "The Rising Ceremony is Subject of the New Mural Above Door in Post Office," *The Livingston Enterprise*, June 1940.

3. Chisholm to Rowan, June 13, 1940.

4. Ibid.

5. *The Livingston Enterprise*, June 1940.

6. Ibid.

7. Sophie and Paul Crane, *Tennessee Taproots* (Old Hickory, Tennessee: Earle-Shields, 1976), p. 80.

8. *The Livingston Enterprise*, June 1940.

Margaret Covey Chisholm, *The Newcomers* **(detail)**

MANCHESTER

The post office mural in Manchester, located in Coffee County, in the middle section of the state, was painted by Minna Citron, who also was given the commission to paint the Newport mural.[1] The oil on canvas painting, measuring eleven feet eleven inches by five feet, hangs behind the counter in the new post office building on Hillsboro Highway.[2] Since horse swapping was a weekly event in Manchester in the early 1940s, the artist chose the title "Horse Swapping Day" for the mural. The day took on a festive air as politics, marketing, and country humor were all part of the goings-on.

The Description and Composition

Miss Citron visited the Coffee County area and researched local customs and history before deciding on the subject matter for the painting. However, after she returned to her New York studio to execute the mural, she found that she was having problems drawing horses that were very convincing. In a letter from Mr. Ed Rowan in Washington, D.C., the cartoon (full-size drawing) she had submitted to the Section received the following criticism:

> Your cartoon has been studied by the members of the section and I regret to inform you that in our opinion this is not up to your standard. The drawing is entirely unsatisfactory in the central portion. The three animals are questionable and particularly the colt which in part has the characteristics of a calf. The man leaning on the horse is not convincingly drawn to begin with and secondly, question is raised at his apparent familiarity. Most men who handle horses would hesitate to lean on the animal at this point. On the right, the body of the animal and the front part of the wagon to which he is harnessed are not realized. The wagon on the extreme left seems out of scale with the animals in front of it. It is

frankly our feeling that this work does not reflect sufficient checking with the elements introduced into the composition and I look forward to a photograph showing the revisions.[3]

This was scathing criticism to say the least, but being the trooper that she was, Minna Citron set about making the corrections. Fate seemed to lend a hand. Horses for a rodeo at Madison Square Garden arrived in town. Among them was "Gene Autry's horse, Champ Jr., a perfect example of a Tennessee Walking Horse."[4] In a letter dated November 4, 1941, she wrote, "I trust that you will find that my stay at the rodeo has proven beneficial to my horses. Gene Autry and his publicity man are delighted that Champ, Jr. will be immortalized in my mural for the Manchester Post Office."[5]

The staff in Washington was pleased with the changes, and the new cartoon was approved. The mural was completed during early spring, and a letter by the postmaster, Mr. Hugh Doak, indicated that it had been satisfactorily installed by April 10, 1942.[6]

The old brick buildings in the background give the painting a local flavor. A man waves in the distance to a barefoot youngster sitting on a horse without a saddle as an older boy steadies another horse hitched to a wagon. In the center, a foal nurses from its mother while a farmer in rough clothing, hands on hips, looks on. On the far right, another man, with sleeves rolled up, sits with a woman wearing a sun bonnet. Two large shade trees just right of center hold the composition together. The elements of the picture are arranged informally, with the three horses in the center forming a point of interest. The two brick buildings and the smaller horses and wagon function as a supporting cast to that central activity, adding both depth and unity to the painting. The color system is objective, from the red brick buildings to the white blaze down the forehead of Champ Jr. "The mural has recently been beautifully restored by the Texas art conservation firm Kennedy

and Associates."[7] It is a testimonial to times gone by. Some say those were the "good ol' days." Maybe they were.

The Mural's Relation to History

The title of the mural, *Horse Swapping Day*, is very appropriate for Manchester and the Coffee County area. The county was established in 1836 from parts of Bedford, Warren, and Franklin counties. The famed Tennessee Walking Horse had its beginning in Manchester shortly after the turn of the twentieth century, and the area still produces some of the world's finest horses. Local stockmen take great pride in this achievement. In 1935, the Tennessee Walking Horse Breeders Association of America was organized. "A horse by the name of Roan Allen F-38 became the first of what is now known as the Tennessee Walking Horse."[8] Each year these beautiful animals are shown and paraded in a festive celebration at Shelbyville. The Tennessee Walking Horse shows began during the summer of 1939.

Coffee County was named for Gen. John Coffee, who fought with Andrew Jackson at New Orleans in the War of 1812. He also fought with Jackson in the Creek Indian War. Others in the county fought in the war with Mexico, upholding the area's reputation of being both democratic and patriotic.[9] In 1941, Camp Forest became the induction center for Tennessee. During its three years of operation, 250,000 military inductees were processed.[10]

Important also to Coffee County is a historical site called the "Old Stone Fort." It is the remains of a stone fortification a short distance from Manchester. Nobody knows why it was put there or who built it. Some say it was erected by Welsh voyagers who entered the United States from the Gulf of Mexico in the twelfth century; others say it was built by Indians.

The first Circuit Court of the county was organized in June 1836 at the Old Stone Fort Tavern near the Main Stone Fort Spring.[11] The location upon which Manchester was founded in 1836 was for many years known as "Old

Stone Fort" and was a post hamlet on the stage road from Winchester to Nashville. Manchester was named after Manchester, England, because its founders believed that it would become a great manufacturing city due to the water power available on the Big and Little Duck rivers nearby.[12] That did not happen. It is still a relatively small, quiet, peaceful place to live and work.

The Artist

Minna Citron went on to a long and fruitful career as a creative artist. With the energy of a person much younger she continued to work until well past ninety. (Total biographical information about the artist is located in the Newport section.)

1. Rowan to Citron, February 7, 1941.
2. "Horse Swapping Day Mural Back in Post Office," *Tullahoma Times*, May 3, 1989.
3. Rowan to Citron, August 25, 1941.
4. Citron to Rowan, October 11, 1941, New York.
5. Citron to Rowan, November 4, 1941.
6. Doak to Rowan, April 10, 1942, Manchester, Tennessee.
7. *Tullahoma Times*, May 3, 1989.
8. Corinne Martinez, *Coffee County: From Arrowheads to Rockets* (Tullahoma, Tennessee: Coffee County Conservation Board), p. 109.
9. Ibid., p. 14.
10. Ibid., p. 300.
11. Basil B. McMahan, *The Mystery of the Old Stone Fort* (Nashville, Tennessee: The Tennessee Book Co., 1965), p. 10.
12. Ibid.

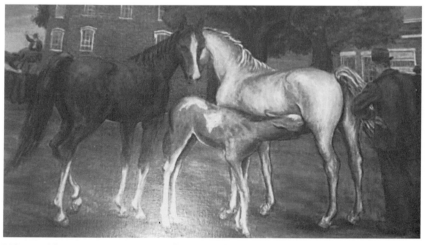

Minna Citron, *Horse Swapping Day* (detail)

McKENZIE

Fantastic, beautiful, and outstanding are just three of the many words people use to describe the post office mural in McKenzie. It has recently been restored, and its appearance is bright and refreshing. It was painted by Karl Oberteuffer of New York and Memphis.[1] The oil on canvas painting is nine feet six inches by five feet.[2] The title is *Early United States Post Village*.[3]

The mural was originally installed in the old post office in early August 1938.[4] In a letter to Ed Rowan the artist stated, "There were many who saw the mural, and all seemed to be pleased with it. All comments were favorable and the postmaster was obviously proud of it. He and his employees cooperated with us to the limit. The postmaster liked it so well that he expressed a desire for decorations all around the lobby."[5]

According to Mr. Byron Pate, postmaster, the cost of cleaning and restoring the mural was about $10,000.[6] Considering the viewing pleasure that has been secured for postal patrons for many years to come, the money was well spent.

The Description and Composition

A person looking at the painting sees many things happening simultaneously. The log cabin on the left is the post office. The mail has just arrived by the covered wagon pulled by two mules. Near the stagecoach in front of the post office stands a woman passenger wearing a black bonnet and long hoop-type dress. A worker unloads her valises. Three men to the right of the mail wagon are dressed in typical frontier attire. One wears a coonskin cap and deerskin shirt while one just behind him stands with a gun on his shoulder as if standing guard over the entire affair. A third, looking somewhat like a cross between a farmer and a cowboy, sits astride a horse, perhaps with intentions of pursuing the "maverick" dog just to his left. In the foreground, two pioneers toil diligently as they push a

crosscut saw back and forth through a long timber. Unable to bear the screech of the saw, several geese begin to move away.

The representational painting is held together by people appearing at intervals along a path of two diagonals going back into space. The viewer's eyes follow these diagonals first to the right and then back left after reaching the person astride the dark horse. The composition is exciting and aesthetically pleasing. Colors are sparkling and clear, with variations of browns, tans, and yellows distributed throughout the short grass.

The Mural's Relation to History

McKenzie, in Carroll County, is a part of that land in West Tennessee that was settled after Tennessee had become a state. While the East became populous and thriving, the western part of the state remained primitive. It wasn't until after 1825 that pioneers began moving rapidly toward Carroll County. Many traveled by wagons, sometimes ten to fifteen miles a day. Others came by flatboats down the Cumberland and Ohio rivers to the Mississippi, and then up the Forked Deer River to their destinations. They built cabins near the rivers, not only in expectation of future travel, but for the water and the rich soil sometimes found near them. There was wild game for hunting, including deer, turkeys, and buffalo. The Indians in the area were Chickasaws. They were friendly to the pioneers, who learned much from them. Both Daniel Boone and Davy Crockett hunted in Carroll County.

By 1867, the railroad had entered McKenzie, and the town grew rapidly after that. The first post office had begun operation in 1866, and by 1890 first class mail was two cents an ounce. The city became incorporated in 1869. Initially the place was like most frontier towns, rough and backward. Pigs, chickens, horses, and cows ran loose in the streets. There were many saloons where people drank and fought.

Eventually, through perseverance of the population, the

town cleaned itself up and began to grow and prosper. Aided by automobiles and trains, the area grew rapidly in the early 1900s. Cotton, tobacco, and corn were grown for local and regional use. McKenzie became a recognized trade center for that section of the state. With the coming of electricity in the 1930s and '40s it continued to grow, and today McKenzie is a modern city with a flavor that is both Southern and Midwestern.

The Artist

Karl Oberteuffer was born August 9, 1908, and received his early art training in Croisic, France.[7] Much of his schooling in painting came from his parents, George and H. Amiard Oberteuffer, who were both artists and teachers. At one time his mother was on the faculty of the Memphis Academy of Art.[8]

The artist was also a student at the prestigious Chicago Art Institute, where "he won the coveted Peabody award for painting in 1928, at the National exhibition."[9]

Although the McKenzie mural is in oil, Mr. Oberteuffer's reputation was achieved in the difficult medium of watercolor. About an exhibit in Cambridge in October 1941, the *Christian Science Monitor* said, "Mr. Oberteuffer does not choose the easier path; nor does he sit back complacently once something effective has been contrived by his brush. There is perceptible in his pictures an eagerness and striving for something expressive and well communicated. He is trying to say more with each new attempt with less expenditure of means."[10]

The Oberteuffers described themselves as "one of the paintingest families in the country."[11] Mrs. Oberteuffer, who was born in Le Havre, met her husband in Paris, where they were both painting. After they married, Karl was born. They returned to the United States in 1926.[12] Much of their life after that was spent in the Boston and Cambridge, Massachusetts, area where they continued to paint. While his mother painted still lifes and portraits, Karl was becoming adept at painting landscapes and seascapes in water-

color.

After one painting session, he related the following humorous incident:

> I was painting near the hotel Vendome and without realizing it, I was sitting in front of the Russian Relief Office, and part of the flag was in the painting. Suddenly this plump dowager strolled up, took a look at the painting, saw the red flag, and then sniffed and said in a very austere and disapproving manner, This is much too nice a day for a communist to be painting here. And then strode majestically off.[13]

Throughout his career, artist Karl Oberteuffer worked at various times for the United States government. In 1936, he was sent out on a battleship by the Treasury Art Project to make sketches of activity aboard ship. He spent several weeks aboard as the craft was put through its tests in a shakedown cruise up and down the coast.[14]

He also painted a mural for the Falmouth, Massachusetts, Post Office in 1942.[15] Fifteen years later, on January 14, 1958, the *Falmouth Enterprise* reported his death at the youthful age of forty-nine.[16] It was a life well spent but over much too soon. His record of awards and exhibitions includes many major museums: the Corcoran, Washington, D.C., Carnegie, Pennsylvania Academy, National Academy in Los Angeles, Whitney, and the Institute of Modern Art in Boston.[17]

1. "Pioneer Days Depicted in New Post Office Mural," *The Weekly Banner*, August 19, 1938.
2. Rowan to Oberteuffer, December 18, 1937.
3. Rowan to Oberteuffer, March 25, 1938.
4. O.K. Martin, Postmaster, to Rowan, August 19, 1938, McKenzie, Tennessee.
5. Oberteuffer to Rowan, August 11, 1938, Gloucester, Massachusetts.
6. Interview with Byron Pate, July 1992.
7. Peter Hastings Falk, *Who Was Who in American Art* (Madison, Connecticut: Sound View Press, 1985), p. 456.
8. Marlene Park and Gerald E. Markowitz, Democratic Vistas: *Post Offices and Public Art in the New Deal* (Philadelphia: Temple University Press, 1984), p. 89.
9. "Boston Artist's Water Colors Currently Shown in Two Cities," *Boston Traveler*, October 1941 (Information supplied by Archives of American Art, Smithsonian Institution).

10. "Oberteuffer Watercolors," *Christian Science Monitor*, October 1941 (Information supplied by Archives of American Art, Smithsonian Institution).

11. "Mother and Son Form Painting Team," *The Boston Daily Globe*, June 12, 1946 (Information supplied by Archives of American Art, Smithsonian Institution).

12. Ibid.

13. Ibid.

14. *Boston Traveler*, October 1941.

15. "The Post Office Mural," *Falmouth Enterprise*, August 27, 1986.

16. "The Artist Painted Well for Falmouth Post Office," *Falmouth Enterprise*, January 14, 1958 (Information supplied by Archives of American Art, Smithsonian Institution).

17. Falk, p. 456.

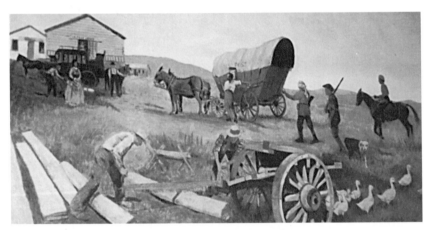

Karl Oberteuffer, *Early United States Post Village*

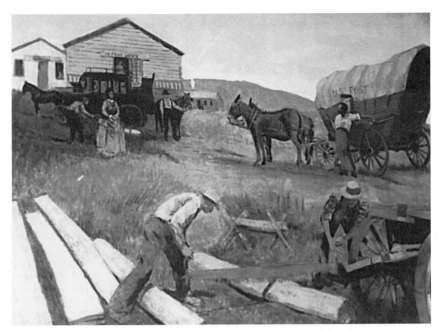

Karl Oberteuffer, *Early United States Post Village* (detail)

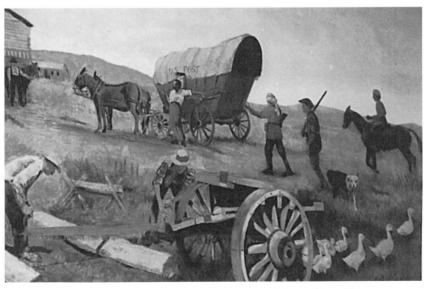

Karl Oberteuffer, *Early United States Post Village* (detail)

MOUNT PLEASANT

Mount Pleasant is about a fifteen-minute drive south-west of Columbia. In February 1942, an artist from New York named Eugene Higgins was commissioned to paint a mural for their post office.[1] The mural was requested by the postmaster, Mr. Mumford S. Stewart.[2] Mr. Stewart reasoned that if Columbia could have a mural painted for their post office, then Mount Pleasant should also have one.

It was installed October 26, 1942, and is a tempera and oil painting on canvas entitled *Early Settlers Entering Mount Pleasant*.[3] The dimensions are twelve feet six inches by five feet three inches.[4]

The Description and Composition

The mural is a portrayal of white settlers with their black slaves coming through a wide valley between lush green rolling hills. At the front of the caravan, the leader sits on a beautiful black and white horse as the wagons form a column on a dirt road that zigzags back into space. The wagons are open and crowded, indicating either short travel distances or night encampments. In the first wagon, pulled by mules, a man in the rear picks a banjo. The time is summer. Some people have shirt sleeves rolled up and there is growing vegetation.

To the right of the first wagon, a young black man drives the family cow while another farther back spreads his arms in an effort to control a small herd of sheep. People and animals are heavily modeled, enhancing their three-dimensional quality considerably. The painting is a pleasant mixture of various shades and tints of greens and tans, complemented by the bright clothing of the people in wagons. The soft-edged representational look of the work is compatible with the aesthetic philosophy of many Tennessee postal patrons.

The mural is well done and is a wonderful addition to the post office, but societal issues have changed a great deal in the last fifty years. The subject matter may not be

as acceptable as it once was.

The Mural's Relation to History

The theme of the painting is historical. It is a depiction of pioneers entering the area with wagons filled with slaves and other belongings.[5] The idea was taken from a discussion with a woman from Pennsylvania named Suzanne Kenyon.[6] It seems that she had met Mr. Higgins while attending an exhibition of his paintings. After learning that he intended to paint a mural for Mount Pleasant, she related to him the following story:

> My family from away back came from Mount Pleasant and is still there. My great-great grandmother said that her husband, named McNish, came to that region on horseback leading wagons filled with slaves.[7]

As things turned out, the woman later said in a letter to Ed Rowan, assistant chief of the Fine Arts Section, that she had been misunderstood. She said she thought she had made it clear that her great-great grandfather had settled at what is now Brentwood.[8] However, the other information is accurate. The settlers did trek from Virginia with wagons and slaves. So the theme was appropriate for Mount Pleasant.

The mural was completed in the artist's studio in New York. Before it was shipped to Tennessee, it was seen by a former New York Giants baseball pitcher who said that he had lived in Mount Pleasant. He informed the artist that the mules pulling the wagons looked like sturdy Tennessee mules instead of the specimens seen in the New York-Connecticut area.[9]

Among the early settlers was a man named John Hunter. He came to the Mount Pleasant area about 1806 and eventually became prosperous and prominent.[10]

Mount Pleasant received its first charter in 1824, another in 1899, and finally a permanent one in 1907. In

1890, it had a population of about 466, and it grew somewhat rapidly toward the turn of the century due to the "discovery of phosphate in 1895."[11] Several large mining and fertilizer companies moved into Maury County and began operations in Mount Pleasant. During the early 1900s it became the center of the phosphate interests in the state, and a number of citizens became wealthy due to ownership of phosphate land.

The Artist

Higgins, the son of a stonecutter, was born in 1874 in Kansas City, Missouri. He studied art in Paris under the tutelage of Jean Paul Laurens and Jean Gerome.[12]

He was an artist who was concerned with the social conditions of people. His paintings did not detail actual situations. They were general in nature rather than indications of specific locations or events. He painted the tragedies of people and was concerned with their misfortunes and living conditions.[13]

Even so, he presented them as human beings with dignity and proudness. The fact that they were without homes

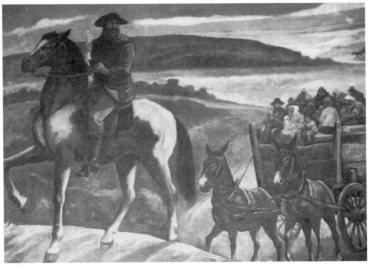

Eugene Higgins, *Early Settlers Entering Mount Pleasant* (detail)

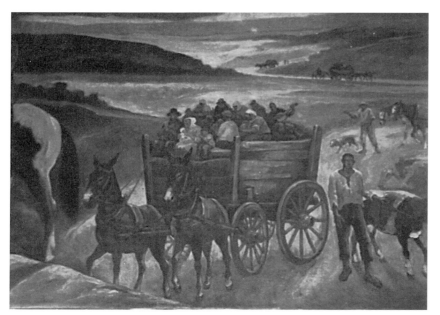

Eugene Higgins, *Early Settlers Entering Mount Pleasant* (detail)

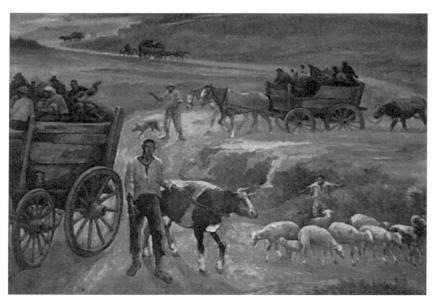

Eugene Higgins, *Early Settlers Entering Mount Pleasant* (detail)

or great financial resources did not keep him from portraying them in a "romantic and sentimental fashion."[14]

Throughout his long career, Higgins' work was shown in many exhibitions. His paintings are in various collections, including the Los Angeles Museum of Art, William and Mary College, the Museum of Modern Art, the Whitney Museum of American Art, the British Museum of Art, and the New York Public Library. He also painted murals for post offices in Beaver Falls, Pennsylvania, and Shawano, Wisconsin.[16] Eugene Higgins died in 1958.[16]

1. Rowan to Higgins, February 11, 1942.
2. Stewart to Simon, September 29, 1941, Mount Pleasant.
3. Higgins to Rowan, October 26, 1942, Nashville.
4. Rowan to Higgins, February 11, 1942.
5. Higgins to Rowan, March 27, 1942.
6. Kenyon to Rowan, January 3, 1943, Moonlight Hills, Pennsylvania.
7. Higgins to Rowan, March 30, 1942, New York.
8. Kenyon, to Rowan, January 3, 1943.
9. Higgins to Rowan, October 1, 1942, New York.
10. William Bruce Turner, *History of Maury County, Tennessee* (Nashville, Tennessee: The Parthenon Press, 1955), p. 73.
11. Ibid., p. 76.
12. Michael David Zellman, *American Art Analog, Volume III, 1874-1930* (New York: Chelsea House Publishers, 1986), p. 761.
13. Ibid.
14. Ibid.
15. Peter Hastings Falk, *Who Was Who in American Art* (Madison, Connecticut: Soundview Press, 1985), p. 281.
16 Zellman, p. 761.

NEWPORT

Newport, nestled in the foothills of the Smokies, has the largest mural in the state. It was originally installed in the old post office the week of October 28, 1940.[1] The huge oil on canvas painting by Minna Citron, a New York artist, is forty-eight feet by seven feet six inches.[2] It is entitled *TVA Power*.[3] The project required a period of two years for completion at a cost of $1,650.00.[4] When the new post office was constructed in 1977, Ms. Citron's painting was removed and sent to the Smithsonian Institution in Washington, D.C.[5]

On November 1, 1980, the mural was returned from Washington to Newport.[6] This was accomplished through an effort by local newspapers, the county historian, and Congressman James Quillen to secure its return. It now hangs in the DAR museum but is very difficult to see in its entirety because it is so large and museum space is limited.

The Description and Composition

The subject matter of the mural is concerned with various segments of life in East Tennessee. A farmer wearing typical bibbed overalls plows corn with a tractor while several workmen handle canned goods in a building covered by a striking red tile roof. A horse pulls a wagon loaded with sacks away from the businesses of the city farther back in the picture. Jerseys graze on the grass as other cows stand in a circle below what appear to be milking machines representing the dairy industry. A sow eyes another worker being pulled by a Caterpillar tractor. Electric power lines supported by strong towers soar overhead, lacing the composition together, as repetitions of triangular shapes representing gable ends of business buildings and houses create harmonious relationships from one end of the long mural to the other. High quality draftsmanship is evident throughout by the definitive use of lines within certain objects such as farm machinery. All elements represent the future progress made possible by the

Tennessee Valley Authority. It is unfortunate that the space in which the mural is hung makes it difficult to view in its entirety.

The Mural's Relation to History

When she received the commission to paint the Newport mural in 1938, the artist decided to travel to the local area and spend several weeks sketching and talking to the citizens in order to develop a "feel" for the people who lived there. She made drawings of farming equipment, local buildings, and TVA dams. In order to gain knowledge about Norris and Chicamauga dams, she questioned engineers on their construction and use.[7]

After the mural was completed, and before it was installed in the post office, it was shown in a special exhibit at the Art Students League in New York. Eleanor Roosevelt was an honored guest at the reception.

The buildings in the mural were so accurate that a woman, upon viewing it, exclaimed, "Lawd a' mercy, if it ain't the high school!"[8] Mayor Lloyd Nease was most gracious in a letter to Miss Citron dated November 1, 1940. In it he said:

> I want you to know how very much we, the people of Newport, like the murals you have painted for our post office walls. The whole town is loud in its praise of the manner in which you have shown the many activities of this section of the country. The TVA background is excellent, but what we like best is the way you have shown our industries and buildings of Newport. We feel that we are extremely fortunate in having our post office chosen for these paintings, and that they will serve as an attractive drawing card for the many tourists and visitors who come to our town.
>
> And too, I do not know any "furriner" (as the mountain people would say) that has captured our hearts as you have. You have made many friends while here, and your interest in the people of this section and the

friendships made will further endear the murals to us. We shant forget your kindness and patience in explaining your work to all of us who asked so many questions![9]

Newport, home of the Stokely Van Camp Corporation and a part of Cocke County, began operation as a city in its present location in 1867, two years after the end of the Civil War and the same year the railroad from Morristown was completed. It became the county seat in 1884.

The county, named for Senator William Cocke, an important government official in the short-lived State of Franklin, was settled by Pennsylvania Germans in the 1780s. These early settlers generally lived in the vicinity of one of the many forts in the area, which provided sanctuary from the Indians. Many Indian artifacts have been unearthed just north of "The Nation," a section of the county that supported a large number of the Cherokee Indians.

Since those early times, people have transformed the landscape in many ways. They cleared the land, plowed fields, and planted crops of tobacco, corn, wheat, barley, and other grains. They brought livestock, and the dairy industry flourished. Numerous logging camps and sawmills dotted the county in the 1920s and '30s, and trees were turned into lumber for furniture and housing. Today, Cocke County, including Newport, is both agricultural and multi-industrial. Many famous people have visited or have come to settle, including Andrew Jackson, Henry Clay, Sam Houston, Andrew Johnson, James K. Polk, and the distinguished writer Wilma Dykeman.

The Artist

Minna Citron's childhood was spent in Newark, New Jersey. By the time she was twenty-eight, she was married and the mother of two children. About then, she became interested in art and enrolled at the New York School of Applied Design for Women.[10] Later, she studied at the Art Students League with such notables as "Kenneth Hayes

Miller, Harry Sternberg, and Kimon Nicolaides, the famous drawing instructor."[11] In 1934, she was divorced from her husband, "whom she described as loving money, gold, and cigars—values very different from her own."[12] From that time on, she supported herself and two children as an art teacher, painter, and printmaker. She never regretted her choice and the freedom it afforded for her to pursue an artistic career. She moved to Union Square in Manhattan and became part of a group of professional artists, including such painters as Isabel Bishop and Reginald Marsh.[13] As a part of Roosevelt's New Deal, she taught painting in New York before becoming a muralist in 1938.[14]

In 1942, she began to move toward abstraction.[15] Soon she was making prints as well as paintings. During her experimentation with various media, she developed a method of incising a thickly painted surface, ensuring a three-dimensional effect to her paintings.

As a teacher, she was active at the Brooklyn Museum School from 1940 to 1944, and later at Pratt Institute, a very well-known school of design.[16] She continued to work day by day and year by year to make visual statements meaningful both to her and to the general public. Her work is found in collections of the Museum of Modern Art, Whitney Museum of American Art, Norfolk Museum of Art and Science, the Newark Museum, and others.[17] After a lifetime of creative work, she died December 19, 1991, in Manhattan at the age of ninety-five.[18] She is now recognized as one of the great women artists of her time.

1. "Hang Mural in Post Office," The Plain Talk and Tribune, October 28, 1940.
2. Ibid.
3. Citron to Rowan, February 23, 1939, New York City.
4. Rowan to Citron, February 1, 1939.
5. Edward R. Walker III, A W.P.A. Mural in Newport, University of Tennessee, December 1, 1982.
6. Ibid.
7. Citron to Rowan, July 10, 1938, Newport.
8. Citron to Rowan, November 9, 1940, Newport.
9. Nease to Citron, November 1, 1940, Newport.
10. Charlotte Streifer Rubenstein, American Women Artists: From Early Indian Times to the Present (Boston and New York: G.K. Hall & Co., 1982), p. 231.
11. Ibid.

12. Ibid.
13. Ibid.
14. Ibid.
15. Ibid., p. 232.
16. Ibid.
17. Peter Hastings Falk, *Who Was Who in American Art* (Madison, Connecticut: Sound View Press, 1985), p. 115.
18. "Spectrum," *Art News* (February 1992), p. 19.

Minna Citron, *TVA Power* (detail)

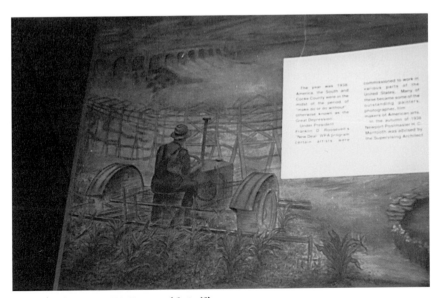

Minna Citron, *TVA Power* (detail)

RIPLEY

Ripley is located at the intersection of Highways 19 and 51 in West Tennessee. In the old post office there is a mural painted by Marguerite Thompson Zorach of Robinhood, Maine.[1] The twelve feet by five feet ten inches oil painting entitled *Autumn* is perhaps the most modern looking of all post office murals in the state.[2] The painting was installed December 12, 1939, by Mr. Burton Callicot of Memphis.[3] Mr. Callicot taught many years at Memphis Academy of Art, establishing a well-deserved reputation as an excellent and very creative painter.

The Description and Composition

As a total work, this composition is a marvelous gathering of simplified shapes. The color quality of these decorative shapes shows the influence of a late Cezanne with its several layers of thin paint producing a luminous appearance. He painted in this manner from 1900 until his death in 1906. The background of beautiful soft yellows, browns, and tans of October interspersed with stylized trees and bushes provides the viewer with a flattened space with a Cubistic orientation. Seeing it is a wonderful aesthetic experience for the people of Ripley.

Descriptively, the subject matter of the picture shows a woman in the foreground catching nuts that are falling from a hickory tree. A boy sitting on the ground rakes up the nuts, oblivious to a writhing snake suspended on a forked stick held by a man directly behind the woman. A long nosed, sleek-looking dog appearing much like a racing greyhound sniffs the ground while another looks back at two men carrying shotguns. The men appear to have stopped for a bit of conversation while making their way through the forest in search of squirrels or other wild game.

The Mural's Relation to History

Ripley, the seat of Lauderdale County, became a city in

1838 and received a new charter April 3, 1901. The charter outlined the city limits as: "Thence North 85 degrees, east to a black gum marked with a cross and with mistletoe in the top, and with a blue bird sitting on a limb, which is a short distance from Ed Johnson's horse lot."[4]

The county was named for Col. James Lauderdale, and Ripley was named for a General Ripley, both soldiers in the War of 1812.[5] Ripley is not far from Henning. It is also near Fort Pillow, where many black troops were killed during the Civil War by Gen. Nathan Bedford Forrest's troops.

Pictorially, the mural does not seem to relate to the early days of the Ripley area (the people's dress is twentieth century), nor does it relate to the 1930s.

The Ripley as we know it today is cotton country. Long flat fields of soft white cotton stretch for miles during autumn. Huge mechanical pickers move back and forth, and there is the smell of cottonseed oil in the air. It is the principal cash crop in West Tennessee, and celebrations are held in its honor, most notable of these being the Memphis Cotton Carnival.

The Artist

Marguerite Thompson was born in Santa Rosa, California, on September 25, 1887.[6] She would become an

Marguerite Zorach, *Autumn*

American painter who favored the French styles of Fauvism and Cubism. She grew up in Fresno, California, and began to draw at an early age.[7] By 1907 she was studying in Paris and becoming acquainted with Picasso and Ossip Zadkine, a young sculptor. At the La Palette School of Art, she met a commercial lithographer from Ohio.[8] They became friends and soon after more than that. By 1912 she was back in the United States painting pictures influenced by Matisse, Derain, and Braque. She later exhibited some of this work at the Royar Galleries in Los Angeles.[9]

In 1912, she married William Zorach. Within five years they had two children and her role as a painter was considerably diminished. She became a homemaker and in her spare time produced tapestries and batiks. Her husband turned his creative energies to sculpting. After 1930, she began working in oils again, but her reputation would not be as strong as William's during any part of her remaining working life as an artist.

Although she continued to exhibit, she produced less and less after 1950. In 1968, she presented her son, Tessim, a roll of paintings done in 1911 and 1912. They were later viewed and written about by art historian Roberta Tarbell, who became aware of their merit as serious works of art.[10] Marguerite Zorach's creations can be found in the collections of the Museum of Modern Art, the Whitney Museum of American Art, and the Newark Museum of Art. She died in Brooklyn in 1968.[11]

1. Marguerite Zorach to Rowan, August 26, 1938, Robinhood, Maine.
2. Morris to Rowan, December 28, 1939, Ripley, Tennessee.
3. Ibid.
4. Department of Conservation, Division of Information, *Tennessee: A Guide to the State* (New York: Hastings House, 1949), p. 422.
5. Sophie and Paul Crane, *Tennessee Taproots* (Earle-Shields Publishing Co., 1976) p. 59.
6. Peter Hastings Falk, *Who Was Who in American Art* (Madison, Connecticut: Sound View Press, 1985), p. 707.
7. Michael Davis Zellman, *American Art Analog, Volume III, 1874-1930* (New York: Chelsea House Publishers, 1986), p. 862.
8. Charlotte Streifer Rubenstein, *American Women Artists: From Early Indian Times to the Present* (Boston and New York: G.K. Hall & Co., 1982), p. 173.
9. Ibid., p. 174.
10. Ibid., p. 176.
11. Falk, p. 707.

Marguerite Zorach, *Autumn* (detail)

Marguerite Zorach, *Autumn* (detail)

ROCKWOOD

Rockwood can be found just off I-40 about thirty-five miles west of Knoxville. The town looks about like it did decades ago. If anything, since the completion of the interstate it has become even sleepier and more peaceful. The post office, the same one that has been there over fifty years, is located on a side street perpendicular to Highway 70, which goes through the center of town. You have to cross the railroad tracks to get to it. Rockwood has the only ceramic mural in the state. The high relief sculpture by Christian Heinrich of New York was cast in a piece mold by the Freigang Ceramic Works of Long Island.[1] Appropriately, the title is *Wild Life.* Mr. Heinrich was paid a total of $760 at the completion of the work. It was finished and installed by November 17, 1939.[2]

The Description and Composition

The large clay wall relief is a family of deer. The buck and doe glance backward as if listening for a sound, while the fawn nuzzles the mother's neck. The seven feet by three feet panel weighs approximately three hundred pounds.[3] The style of the work is naturalistic, and the brown color is analogous to the warm, dark wood of the door below it. The most important design feature of *Wild Life* is that the top of the relief conforms to the outline of the three deer. This feature adds interest to the rectangular severity of the post office wall.

The Mural's Relation to History

Roane County, at the base of the eastern side of the Cumberland Mountains, was named for Archibald Roane, a Greeneville lawyer, member of the Constitutional Convention of 1896, and the second governor of Tennessee (1801). Rockwood itself was named in honor of War of 1812 soldier Maj. W. O. Rockwood.[4] The town was built on land granted to Gen. John Brown, who also served in the war.[5] Before settlement began in 1816, it was the scene of the

first toll gate in the state. The gate was erected and maintained by the Cherokee to prevent the white man's free use of the trail between the Watauga settlement in upper East Tennessee and the Cumberland settlement in Nashville.[6]

The mural's depiction of deer is accurate for Roane County. Not only were they plentiful in the early days of settlement, they still roam freely today. The pioneers hunted them for meat and used the skins for clothing. Raccoons, foxes, skunks, and groundhogs also abound in this region.

Industrially, the county has a considerable amount of mineral deposits in the form of coal and iron, which were mined from 1860 until the 1920s. There are also extensive limestone quarries near Rockwood, adding a great deal to the economy of the county.

The Artist

Christian Heinrich, born in Germany in 1893, attended the Darmstadt Art School from 1906 to 1909. He also studied at the Academie of Art in Munich from 1910 to 1913 and was a pupil of Professor Fritz Behn in Munich from 1913 to 1914. He worked as a mature artist in Germany from 1920 until 1930. He came to New York in 1931 and began work there. His background includes architectural sculpture such as figures and ornamental forms in bronze,

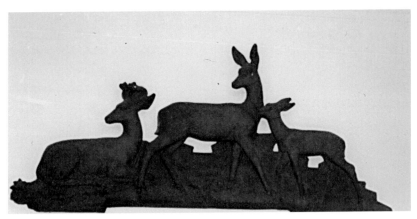

Christian Heinrich, *Wild Life*

wood, and terra-cotta.[7]

1. Heinrich to Hopper, August 6, 1939, Brooklyn, New York.
2. Ibid., November 17, 1939.
3. Hopper to Heinrich, July 5, 1939.
4. Department of Conservation, Division of Information, *Tennessee: A Guide to the State* (New York: Hastings House, 1949), p. 438.
5. Ibid.
6. Ibid., p. 439.
7. "Biographical Document," *National Archives,* Washington, D.C., December 28, 1933.

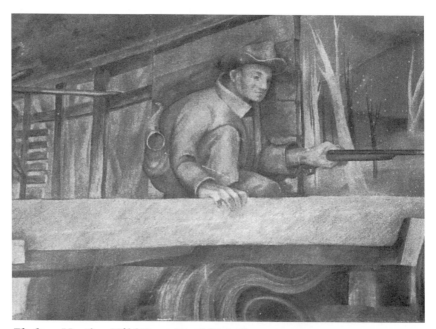

Thelma Martin, *Wild Boar Hunt* (detail)

SWEETWATER

Sweetwater is a busy little town between Athens and Loudon. During daylight hours, traffic moves rapidly along the main thoroughfare through the center of town. Most buildings, including the post office, are small and have been around awhile, projecting the flavor of a country village. David Stone Martin painted the mural for Lenoir City. Just up the road a few miles, his wife, Thelma Martin, painted the one for the Sweetwater Post Office.

The mural on canvas, extending down on both sides of the mantel, was done with a combination of tempera paint, egg yolk, and water.[1] Its muted colors of browns, tans, and grays have darkened with age. The eleven feet by four feet five inches painting entitled *Wild Boar Hunt* was installed in November 1942.[2] J. N. McGuire was the postmaster at that time.[3] The artist, Thelma Martin, was from Lambertville, New Jersey.[4]

The Description and Composition

Compositionally, the painting is a contrast between the biological forms of the men, dogs, and wild boars and the architectural forms of the old mill. The color scheme is a pleasant mixture of grays and browns, fixing the time of year as late fall. As one looks through the mill toward the background, four hunters with guns can be seen in front of a stand of ghostly white trees. At the front left, two hunters stand rather stiffly with four hunting dogs. Another hunter in the center props his leg up on the cross bar as he steadies his gun in a horizontal position. On his back is a horn for calling the dogs.

In the right corner, a ferocious sow at the front of her den glares at a barking dog while a young pig with visible stripes stands nearby. A dead hog hangs from a scaffold in the rear. "The old grist mill (spindle type) in the picture is typical of small mountain mills which dot the region of the boar hunt. Most are abandoned and used mainly as shelters for hikers and hunters."[5]

The Mural's Relation to History

Regarding the title of the painting, Mrs. Martin said, "I chose the subject of a boar hunt because the region in which Sweetwater is located is the principal spot in America where real wild boar is hunted. The East Tennessee boar is a descendent of East European animals."[6] The original boars came from the Hartz Mountains in Germany. They were imported by farmers to provide seasonal sport.[7] They spread over an 80,000 acre area and have greatly increased in number. Being extremely vicious, they furnish exciting sport for hunters.

This area has retained much of its wild feeling. It is filled with cliffs, ravines, and dense plant growth. Mountain laurel and rhododendron are found here in the Cherokee National Forest. This section of Monroe County is the former domain of the Cherokees and is very important in the military, political, and tribal history of that group of people. They lived along the Tennessee, Hiwassee, and Little Tennessee rivers.

Monroe County is also the place where the original Fort Loudoun was built by the British in 1756. Located near the Little Tennessee River, it was erected to provide protection for Cherokees friendly to the British during their war against the French. It was named in honor of the Earl of Loudoun, British commander-in-chief in North America at that time. Angry because they had been ill-treated by the British, the Cherokees burned the fort in 1760.

In 1936, an appropriation for restoration of the fort was obtained from the Works Projects Administration of the federal government; a careful study was made of surviving letters, maps, and records. "The project became dormant in 1937 when the project funding was not supplemented."[8] In the early 1950s work was begun again.[9] Since that time, work has continued periodically, and a museum honoring the famous Cherokee educator Sequoyah has been built near the site on Highway 411 between Greenback and Vonore.

The Artist

Thelma Martin studied at the Art Institute of Chicago during the early 1930s. After painting the Sweetwater mural, she pursued a career in photography in New York City and Roosevelt, New Jersey, from 1940 through 1958. She specialized in city and country life. Her photographs included such people as musicians Leadbelly and Woodie Guthrie. After a long and fruitful career in the visual arts, she died in 1969 at Lambertville, New Jersey.

1. Thelma Martin to Section of Fine Arts, November 26, 1941, Sweetwater, Tennessee.
2. McGuire to Federal Works Agency, December 7, 1942, Sweetwater, Tennessee.
3. Ibid.
4. Thelma Martin to Section of Fine Arts, November 26, 1941.
5. Thelma Martin to Rowan, November 19, 1941, Lambertville, New Jersey.
6. Ibid.
7. Ibid.
8. Paul Kelley, *Historic Fort Loudoun* (Vonore, Tennessee: Fort Loudoun Association, 1958), p. 37.
9. Ibid.

Thelma Martin, *Wild Boar Hunt*

Thelma Martin, *Wild Boar Hunt* (detail)

Thelma Martin, *Wild Boar Hunt* (detail)

EPILOGUE

For the past several years, I have taught a course about the history and philosophy of art in the schools of the United States. One small segment of that involves the federal government's sponsored art programs during the Depression years. After one session when some discussion of post office murals had occurred, one student was prompted to write a short paper about the one that he had seen in Newport, Tennessee. While reading the paper, I decided to find out just how many there were in the state and what kind of condition they were in. That was during the summer of 1991. Since then, I have read books, researched the National Archives in Washington, D.C., made dozens of telephone calls, and traveled throughout the state. It has been a most worthwhile endeavor.

The people I have met have been very helpful and interested in what I was doing. At Dresden, I had a delightful conversation with Mr. Scott Sharp, the postmaster. At Manchester, the postal workers talked about the restoration of the mural and what the subject matter was about. They were quite proud of it. I also received extraordinary help with the Dickson mural. My wife, Novella, accompanied me on this trip, as on most of them, and proved to be an able assistant. After arriving in Dickson late one afternoon and finding the new post office, we learned that the mural was not there. It had been left in the original post office building. We were somewhat concerned because the Dickson mural is the only one in Tennessee that is a fresco painting. A fresco painting is done on a damp plaster wall. As the paint sinks into the plaster, it becomes part of the wall. The finished product seems to have a luminous quality and can only be moved by cutting out a considerable section of the wall. The ceiling of Rome's Sistine Chapel, painted by Michelangelo, is also of the fresco technique. The postmaster, Mr. James Cowan, now retired, was most generous with his help and enthusiasm. He provided assistance in the person of Ms. Judy Striet. She accompanied us

to the building containing the mural and remained there while I photographed and videotaped the fresco. We appreciated the kindness.

I have received press clippings and bits of information from other postmasters and from local newspapers. For all of those I am most grateful. It is not easy to dig up information about a painting that has been in a public building fifty or more years. However, a project like this provides an opportunity to see parts of Tennessee to which one might not ordinarily travel. I doubt that I would have gone to Ripley or Bolivar or Livingston, but I'm glad I did. There was something unique about each place and about the people we met.

As we traveled Highway 30 in East Tennessee toward Dayton, the road suddenly ended and we were confronted by a large body of water. As we sat contemplating the water, a small ferry appeared on the other side. A short time later, it chugged its way across and transported us (still in our car) to the other half of the highway, where we continued on our way. It was enjoyable and exciting to us because it was totally unexpected.

Most of the small towns where the post offices are located were built around a square with an architecturally ornate courthouse in the middle. The pace of activity is pleasant and easygoing. In Dresden there are no parking meters, and businesses open very early. After spending the night in the motel, we had breakfast at *the* restaurant. I remember reading the previous evening's menu carefully lettered on a chalkboard behind the counter. It read: "biscuits, pinto beans, mountain oysters, chitterlings, mustard greens, and homemade pie."

In Rockwood, I met a man who had read the book *Blue Highways*. It had prompted him to travel around the state. After talking to me, he allowed that he might do it again just to see the murals. In Decherd, a place so small that you didn't dare blink for fear of missing it, there is a carved wood mural. As I came out of the post office, a man told me that he knew the man who had carved it—said he did it

about five years back and lived just down the street. Another said it had been carved by a soldier on maneuvers during World War II. Both were wrong, obviously, but still interesting to talk to.

The mural in Greeneville is also of carved wood. Located in a courtroom in the federal building and not easily accessible, it is in two pieces and quite valuable. In order to photograph it, I had to secure permission from Judge Thomas Hull. That took some doing. I had driven up on Friday, the day after Thanksgiving. There was a federal marshal on duty at the entrance. He informed me that I couldn't photograph the mural without the judge's permission and that probably the judge would not be in that day. After pleading my case without success, I got lucky. The marshal looked out the window and told me that the judge was coming down the street. The judge was very cordial as we talked about having the same last name. He permitted me to go upstairs and photograph the mural after I passed through the metal detector, which was not that easy—the gold bridges in my mouth kept setting it off. Finally, the judge remarked with good humor, "I guess we will just have to knock his teeth out."

There were also other interesting experiences. In McKenzie, I spent considerable time talking to a local who was around when the mural was painted. I also received from the current postmaster, Mr. Byron Pate, the name of the man who was postmaster at the time the mural was installed. I later called the former postmaster and received additional information for the project. In Sweetwater, I found out by sheer coincidence that the mural in Johnson City, which I had been led to believe was missing, was indeed not missing. It was installed in the D. P. Culp Center on the East Tennessee State University campus. The new Sweetwater postmaster, Mr. Dave Thomas (who has since retired), had previously held that position at the Johnson City Post Office and knew where the mural had been taken. That was a very fortunate meeting. I later traveled to Johnson City and found the mural to be quite large

and in excellent condition. There were other minor incidents too numerous to mention. The people we talked to, the places we visited, and the things we learned made the writing of this book a rich and rewarding experience.

Howard Hull

BIBLIOGRAPHY

Barton, Patricia, Jim Stokely, and Jeff O. Johnson, eds. *An Encyclopedia of East Tennessee.* Oak Ridge: Children's Museum, 1981.

Beckham, Sue Bridwell. *Depression Post Office Murals and Southern Culture, A Gentle Reconstruction.* Baton Rouge: Louisiana State University Press, 1989.

"Boston Artist's Watercolors Shown in Two Cities." *Boston Traveler,* October (date missing) 1941.

Bullard, Helen, and Joseph Marshall Krechniak. *Cumberland County's First Hundred Years.* Cookeville, Tennessee: Centennial Committee, 1956.

Campbell, T. J. *Records of Rhea, A Condensed County History.* Dayton, Tennessee: Rhea Publishing Co., 1940.

Crane, Sophie and Paul. *Tennessee Taproots.* Earle-Shields Publishing Co., 1956.

Craven, Wayne. *Sculpture in America.* Newark: University of Delaware Press, 1984.

"Dayton Scenery Beats Lookout Mountain Says Artist." *The Herald News,* June 13, 1939.

"David Stone Martin," in *Who's Who in Graphic Art.* Zurich: Amstutz & Herdeg Graphics Press, 1962, p. 520.

Division of Information, Department of Conservation. *Tennessee: A Guide to the State.* New York: Hastings House, 1949.

Dunford, Penny. *A Biographical Dictionary of Women Artists in Europe and America Since 1950.* Philadelphia:

Pennsylvania University Press, 1989.

Falk, Peter Hastings. *Who Was Who in American Art.* Madison, Connecticut: Sound View Press, 1985.

"Farms and Industry United in Mural." *Clinton Courier,* October 21, 1976.

"Fresco." *Dictionary of Artists and Art Terms.* New York: Random House, 1981.

Garrett, Jill K., *Maury County, Tennessee, Historical Sketches.* Columbia, Tennessee: Self Published, 1967.

"Hang Mural in Post Office." *The Plain Talk and Tribune,* October 28, 1940.

Hoskins, Katherine B. *Anderson County.* Memphis: Memphis State University Press, 1981.

Hewitt, Sheila. "Great Mural Hangs Quietly in Post Office." *Crossville Chronicle,* (date missing).

"Horse Swapping Day Mural Back in Post Office." *Tullahoma Times,* May 3, 1939.

Kelley, Paul. *Historic Fort Loudoun.* Vonore, Tennessee: Fort Loudoun Association, 1958.

Livingood, James W. *Hamilton County.* Memphis: Memphis State University Press, 1981.

"Lovers in Marble are Carved by a Leading American Sculptor." *Life,* April 1, 1940.

Marks, Claude. *World Artists 1950-1980.* New York: H.W. Wilson Company, 1984.

Martinez, Corinne. *Coffee County: From Arrowheads to Rockets*. Tullahoma, Tennessee: Coffee County Conservation Board, 1969.

Moore, Sylvia. "Anne Poor." *Women's Art Journal*, (Spring/Summer 1980), p. 50.

"Mother and Son Form Painting Team." *The Boston Globe*, June 12, 1946.

"Mural Adorns Post Office Building." *The Dresden Enterprise*, (Date missing) 1938.

"Mural for Tennessee Post Office by Dahlov Ipcar of Robinhood." *The Bath Independent*, September 15, 1939.

"New Mural for Clinton Post Office Shows Agriculture Industry Harmony." *Clinton Courier*, June 5, 1940.

"Oberteuffer Water Colors." *Christian Science Monitor*, October (date missing) 1941.

O'Conner, Francis V. *The New Deal Art Projects: An Anthology of Memoirs*. Washington, D.C.: Smithsonian Institution Press, 1972.

----------. *Federal Support For the Visual Arts: The New Deal and Now*. Washington, D.C.: Smithsonian Institution Press, 1972.

"Obituary." *New York Times*, January 17, 1954, p. 93, col. 2.

Park, Marlene, and Gerald E. Markowitz, *Democratic Vistas: Post Offices and Public Art in the New Deal*. Philadelphia: Temple University Press, 1984.

"People of the Soil, Subject for Painting at Post Office." *The*

Dickson County Herald, August 18, 1938.

"Pioneer Days Depicted in New Post Office Mural." *The Weekly Banner,* August 19, 1938.

Rubenstein, Charlotte Streifer. *American Women Artists: From Early Indian Times to the Present.* Boston and New York: G.K. Hall & Company, 1982.

Salpeter, Harry. "Marion Greenwood, An American Painter of Originality." *American Artist,* (January 1948), p. 18.

Smith, Johnathan K. T. *Benton County.* Memphis: Memphis State University Press, 1979.

"Speaking of Pictures...This is Mural America for Rural Americans." *Life,* (December 4, 1939), p. 12-16.

"Spectrum" *Art News,* (February 1992), p. 19.

Stewart, G. Tillman. *Henderson County.* Memphis: Memphis State University Press, 1979.

Tarbell, Roberta. *Marguerite Zorach: The Early Years, 1908-1920.* Washington, D.C.: Smithsonian Institution Press, 1973.

"Teak." *Webster's New World Dictionary.* New York: The World Publishing Company, 1956.

"Tennessee: A Guide to the State." *Federal Writers Project.* New York: United States Government, 1939.

"Tennessee." *Rand McNally Commercial Atlas,* 1993 ed.

"The Artist Painted Well for Falmouth Post Office." *Falmouth Enterprise,* August 27, 1986.

"The Post Office Mural." *Falmouth Enterprise*, August 27, 1986.

"The Rising Ceremony is Subject of the New Mural Above Door in Post Office." *The Livingston Enterprise*, June (date missing) 1940.

The World Book Encyclopedia, Vol. 16. Chicago: World Book Childcraft International, Inc., 1980.

Trent, Emma, and Deane Smith. *East Tennessee's Lore of Yesteryear*. Kingsport: Arcata Graphics, 1987.

Turner, William Bruce. *History of Maury County, Tennessee*. Nashville: The Parthenon Press, 1955.

"Unusual Dual Show." *Sunday Times-Democrat*, December 11, 1966.

Vaughn, Virginia C. *Weakley County*. Memphis: Memphis State University Press, 1983.

Other Sources:
 Various letters from the National Archives between the Section of Fine Arts and Artists.
 Biographical documents from the National Archives.
 Newspaper clippings supplied by the Smithsonian Institution's Archives of American Art.

INDEX